OVERSIZE

Russell's Civil War Photographs

Russell's Civil War Photographs

116 Historic Prints

BY

Andrew J. Russell

WITH A PREFACE BY

JOE BUBERGER AND MATTHEW ISENBERG

Dover Publications, Inc.

NEW YORK

Published in Canada by General Publishing Company, Ltd., 30
Lesmill Road, Don Mills, Toronto, Ontario.
Published in the United Kingdom by Constable and Company, Ltd.,
10 Orange Street, London WC2H 7EG.

Russell's Civil War Photographs: 116 Historic Prints reproduces all
the photographic prints in an album (scrapbook) entitled "United
States Military Railroad Photographic Album." The captions have been
adapted, and the sequence of pictures has been altered, in the present
volume, as explained in the Preface on the facing page. This Preface
was written specially for the present edition by Joe Buberger of
North Haven, Conn., and Matthew Isenberg of Hadlyme, Conn., who
made their rare original album available for direct offset repro-
duction.

Manufactured in the United States of America
Dover Publications, Inc.
180 Varick Street
New York, N.Y. 10014

Library of Congress Cataloging in Publication Data

Russell, Andrew J.
 Russell's Civil War photographs.

 1. United States—History—Civil War, 1861–1865—Pictorial
works. I. Title. II. Title: Civil War photographs.
E468.7.R87 1982 973.7'022'2 81-15129
ISBN 0-486-24283-8 AACR2

Preface

by Joe Buberger and Matthew Isenberg

Captain Andrew Joseph Russell (1830–1902), most famous for his Union Pacific Railroad photos of the later 1860s and his other views of the West, was also an official Army photographer during the Civil War, the only such soldier-artist known so far from that war. He enlisted in August 1862. His regiment, the 141st New York Volunteers, was assigned to the defense of Washington until the end of that year, when it was transferred to Belle Plain, Virginia, an important base of operations. Captain Russell received a special assignment to General Herman Haupt's brilliant and inventive U.S. Military Railroad Construction Corps, active in the crucial Virginia sector of the war, where it facilitated the movements of the Armies of the Rappahannock, of Virginia and of the Potomac.

Russell's duties included taking photographs of the work and other experiences of the Construction Corps in order to create a historical record and to be of practical use as guides for similar units elsewhere. The corpus of pictures he produced chronicles not only extensive engineering feats and railroad adventures, but also battlefields, camps, gunboats and combat scenes around Fredericksburg, Petersburg, Brandy and Alexandria, concluding with studies of Richmond in ruins and several immediately postwar operations.

Russell's work was highly valued by the government in Washington at the time, as much for its artistic quality as for its usefulness, and some of his pictures were published in special volumes that were given to visiting dignitaries. Yet his renown as a Civil War photographer was later forgotten and many of his finest efforts were long attributed to Mathew Brady or Brady's associates. Russell has only been rehabilitated in the last few years, largely thanks to the efforts of Civil War photohistorian William Gladstone of Westport, Connecticut, to whom the writers are indebted for many of the data in this Preface.

The Virginia Historical Society in Richmond has long possessed a

scrapbook-type album of 136 actual photoprints bearing the title "United States Military Railroad Photographic Album," and it was to be assumed that other such albums existed and might come to light. It was when Mr. Gladstone began describing another such Russell album that became available to Joe Buberger, Gladstone and Marjorie Neikrug in 1978 that iconographers and photohistorians in Washington and elsewhere were delightedly apprised of the existence of images they had never seen before, such as the funeral car of President Lincoln (see plate 62 in the present volume).

Then, in 1980, the writers of this Preface heard about another copy of the album that was in the possession of Mrs. Barbara Wallis Manies of El Cajon, California (near San Diego). Mrs. Manies had found the album in 1963 in an old chest that she inherited from her grandfather, William Randolph Wallis, a second-hand dealer in Tacoma, Washington. It is this last-named album, which was purchased by the writers, that forms the basis of the present Dover book.

Although all the pictures in the album are included in this volume (except for a faded duplicate of the image on plate 59), they appear in a totally different sequence. The original album was a complete jumble. Here, however, all the pictures that bear a date have been arranged chronologically; here and there a few undated pictures have been placed next to a dated one that was obviously related geographically or themat-ically. The last dated image (the one on plate 81) is followed by three groups of undated ones which it seemed foolhardy to try to integrate into the chronology: a group of Washington scenes (plates 82 through 95), a group of Alexandria scenes (plates 96 through 108), and a miscellaneous group (plates 109 through 116).

The captions, too, have been somewhat modified. In the original album they appear in various forms: printed and pasted in, handwritten or a combination. The spelling, punctuation and other stylistic features are erratic and inconsistent. Many of the pictures are numbered, but the numbering system refers neither to chronology nor the sequence in the original album, and the numbers run much higher than the 116 images in the album. In this Dover edition, all stylistic features have been corrected, modernized or otherwise regularized, and the form of presen-

tation of the information has been made more consistent. Editorial comments, on picture identification and the like, appear in square brackets, as do the numbers the pictures bore in the original album.

Even Civil War enthusiasts of long standing are assured of fresh treats in the present volume, which contains numerous images that the writers have never seen published, even in such books as *Mr. Lincoln's Camera Man*, by Roy Meredith; *Pictorial History of the Civil War*, by Francis Miller; *Mathew Brady, Historian with a Camera*, by James D. Horan; *Battles and Leaders of the Civil War*, by Robert Underwood Johnson and Clarence Clough Buel; and *Civil War Railroads*, by George Abdill. Furthermore, some of the ones that *have* been published appear here with considerably more of the image showing.

The writers will be pleased if their efforts contribute to extend public knowledge of the Civil War and the history of nineteenth-century American photography, and to bring further recognition to the distinguished photographer A. J. Russell.

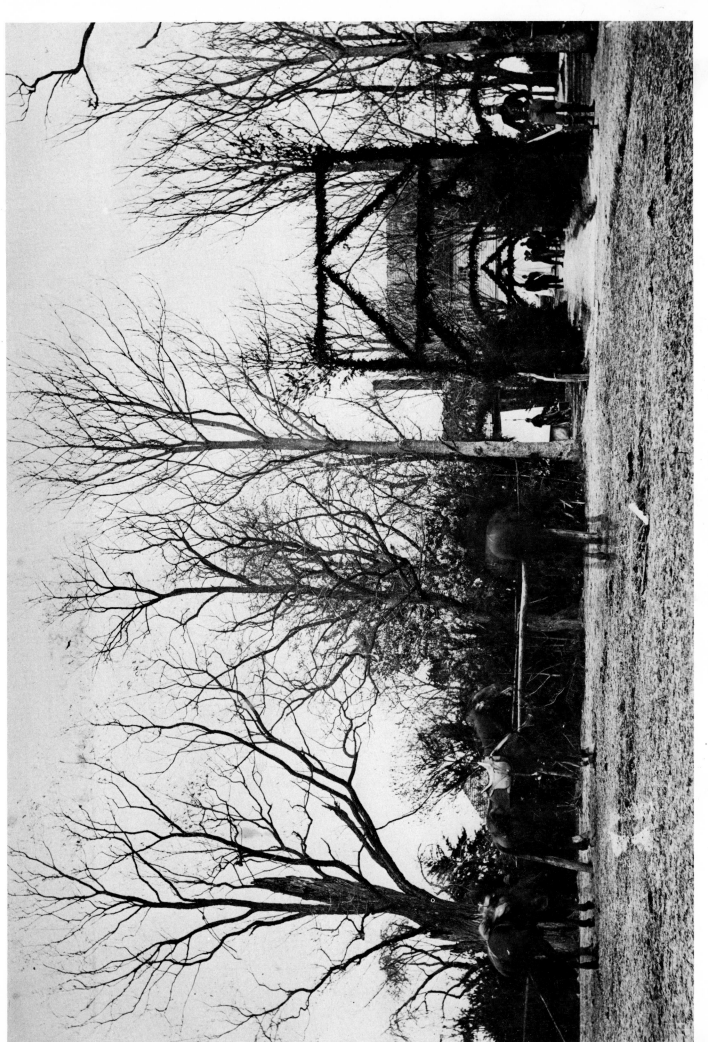

1. General Whipple's headquarters, Falmouth, Va.; April 5, 1863.

[No. 215.]

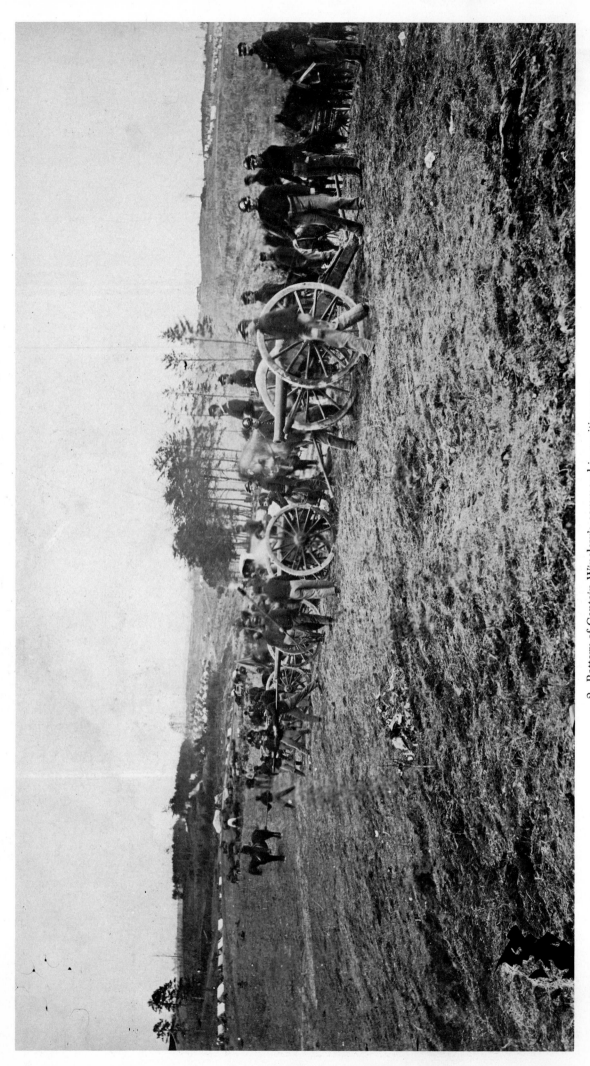

2. Battery of Captain Winslow's command in position near Fredericksburg, Va.; May 2, 1863. [No. 121.]

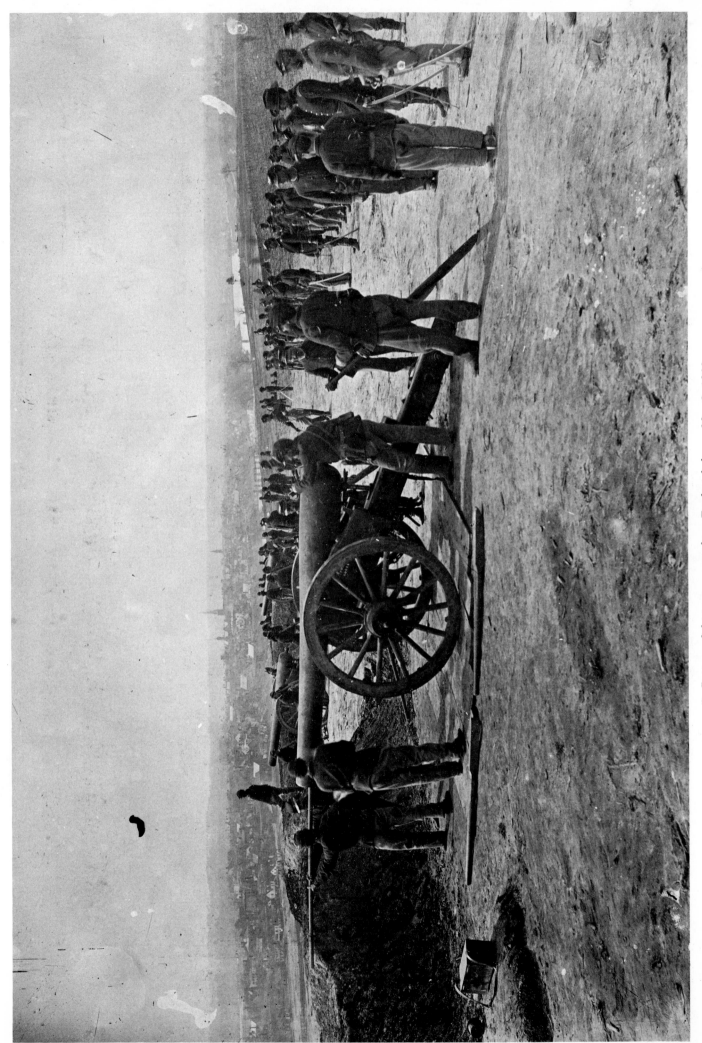

3. Battery of thirty-two-pounders, Fredericksburg; May 3, 1863.
[No. 162.]

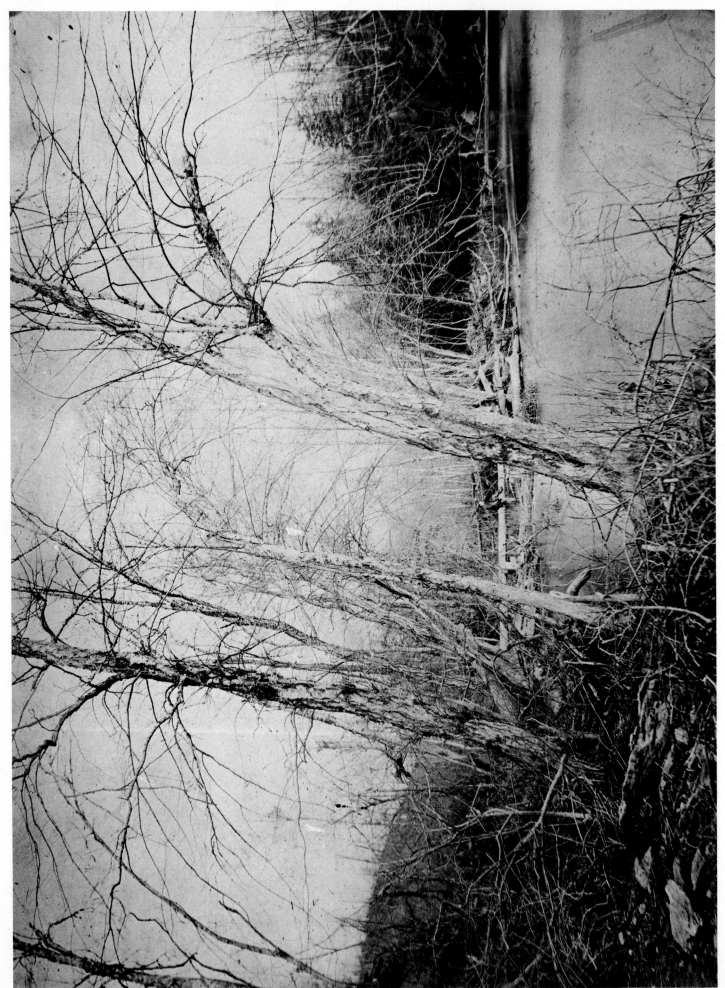

4. Bull Run, near Manassas, Va.; the scene of General Taylor's death; May 1863. [No. 262.]

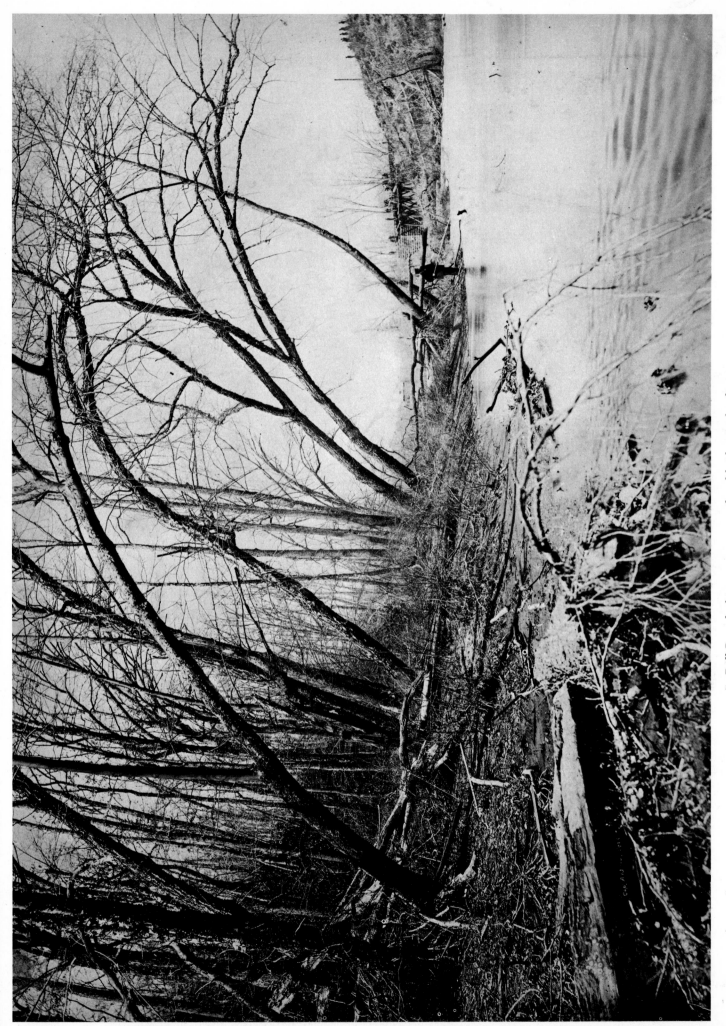

5. Bull Run, looking upstream; railroad bridge in the distance.
[No. 226.]

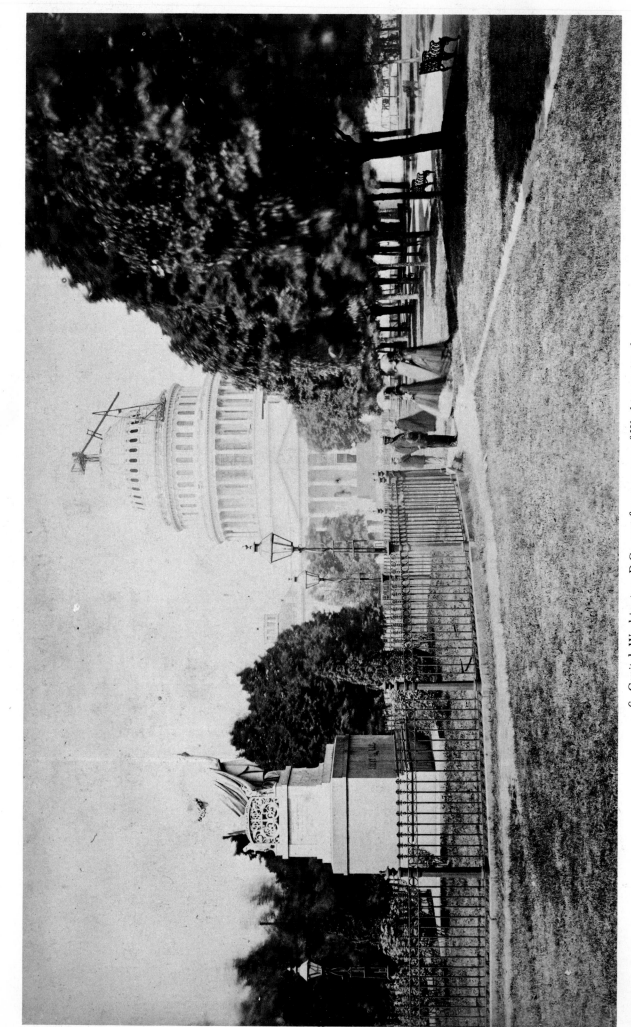

6. Capitol, Washington, D.C., east front; statue of Washington in the foreground; July 11, 1863. [No. 231.]

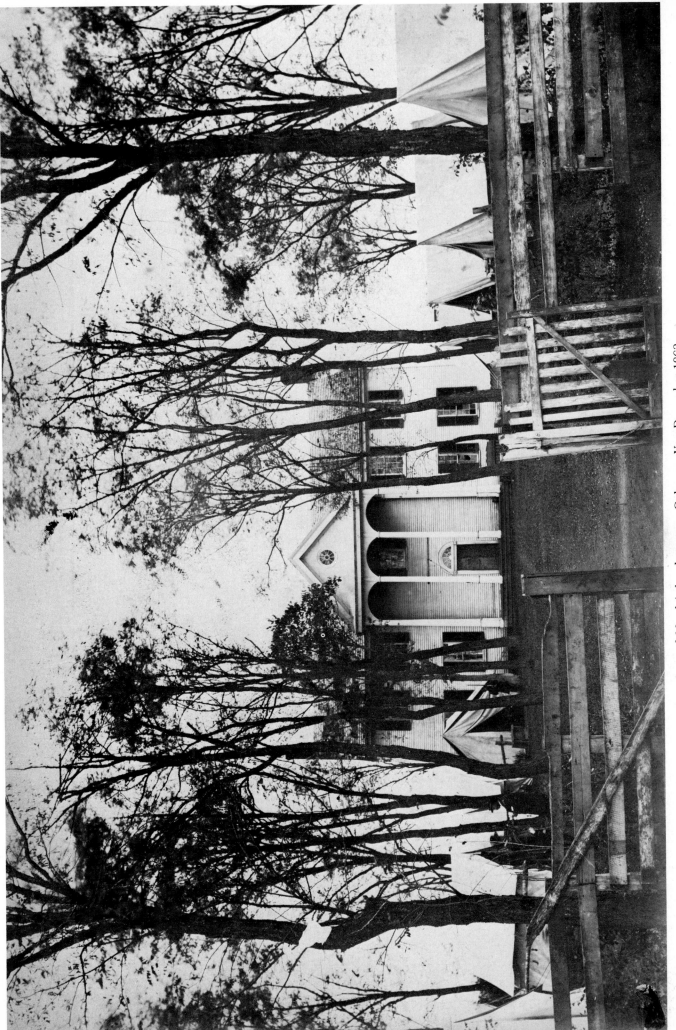

7. General Meade's headquarters, Culpeper, Va.; December 1863.
[No. 150.]

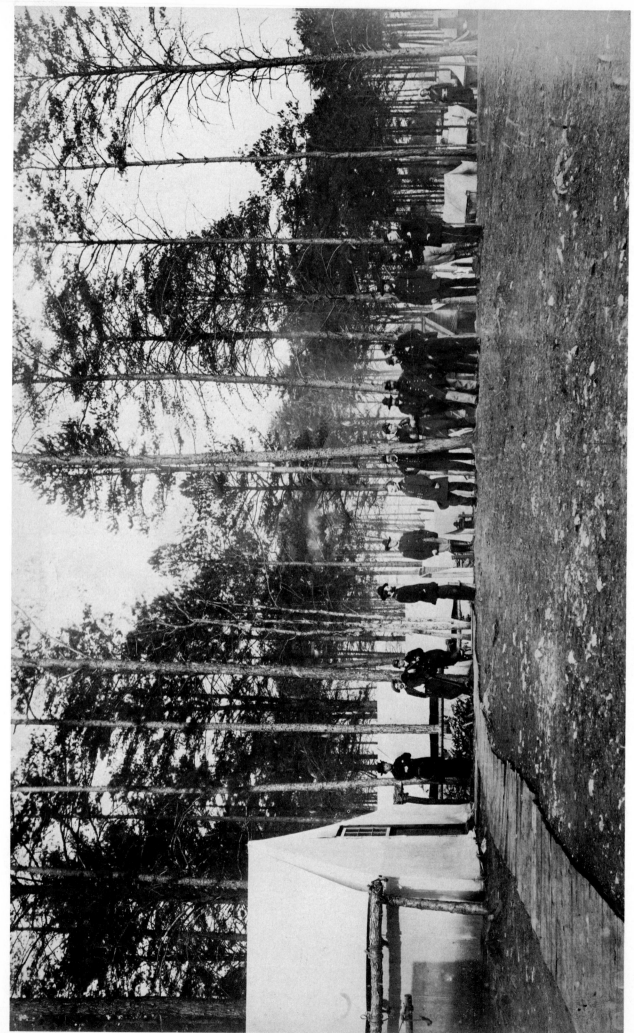

8. General Meade's headquarters, Brandy Station, *Va.*; December 1863.
[No. 150 (*sic*).]

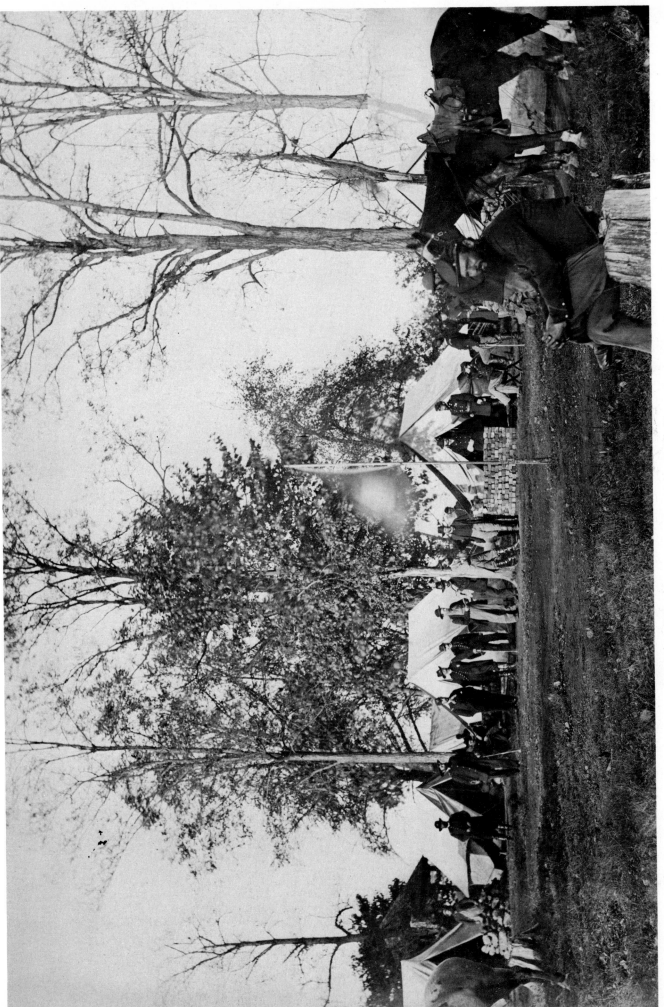

9. General Webb's headquarters, Culpeper; December 1863. [No. 166.]

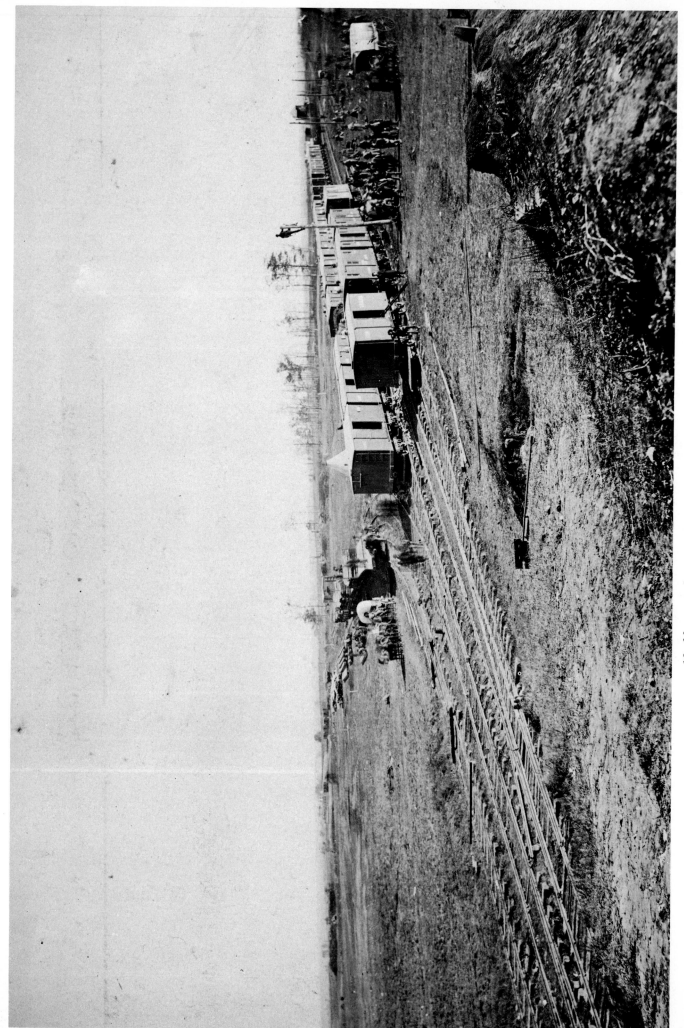

10. Manassas Junction; December 1863. [No. 167.]

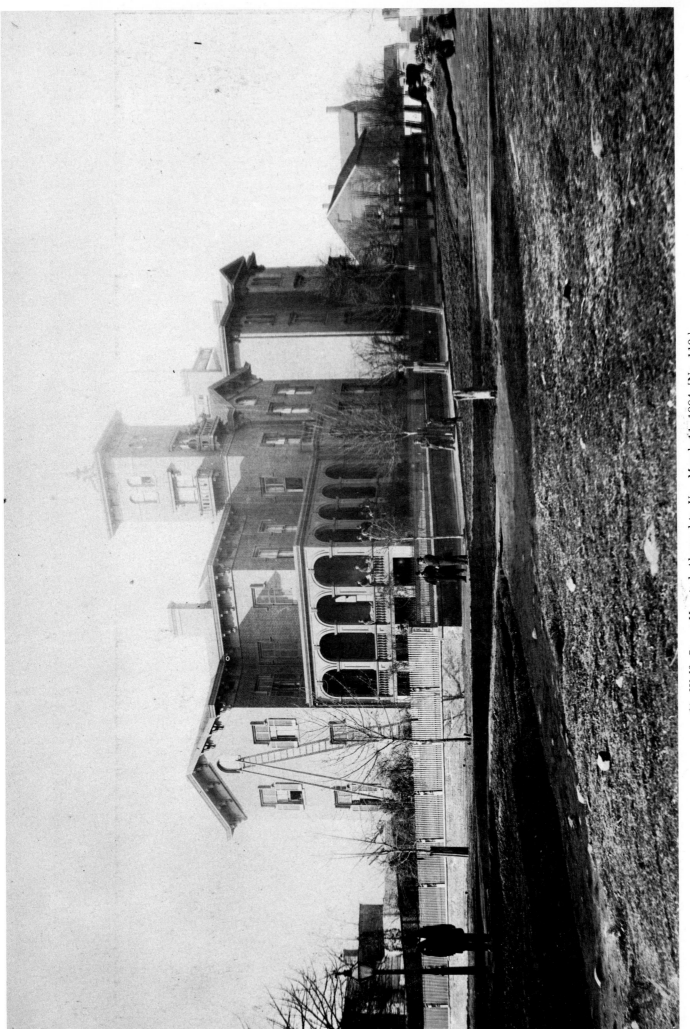

11. Wolfe Street Hospital, Alexandria, Va.; March 11, 1864. [No. 110.]

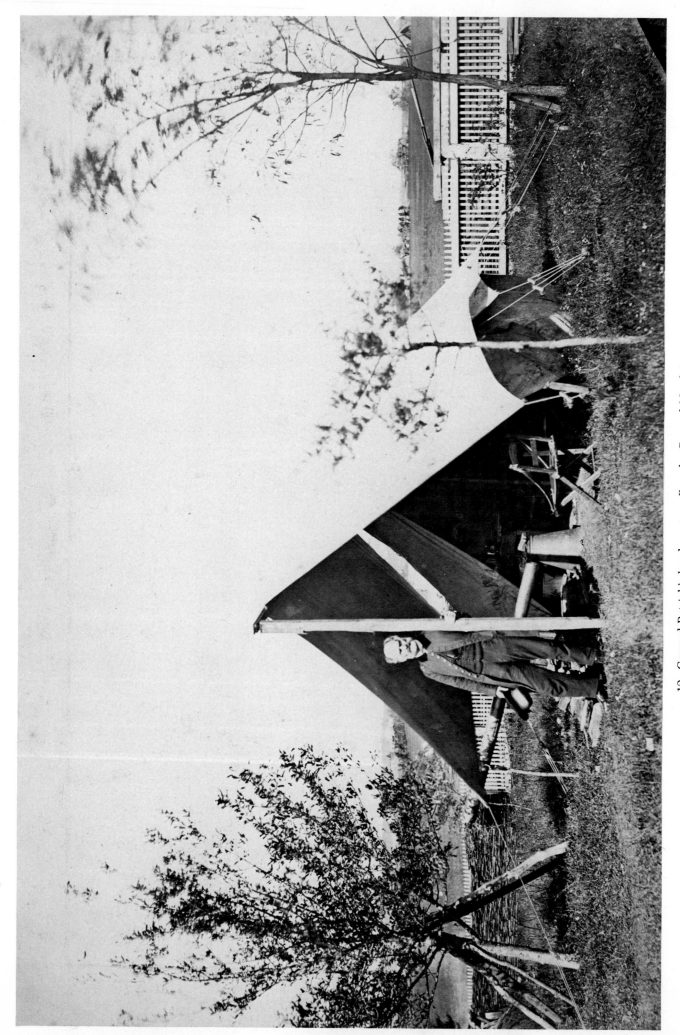

12. General Patrick's headquarters, Brandy; General Meade's headquarters in the distance; April 15, 1864. [No. 112.]

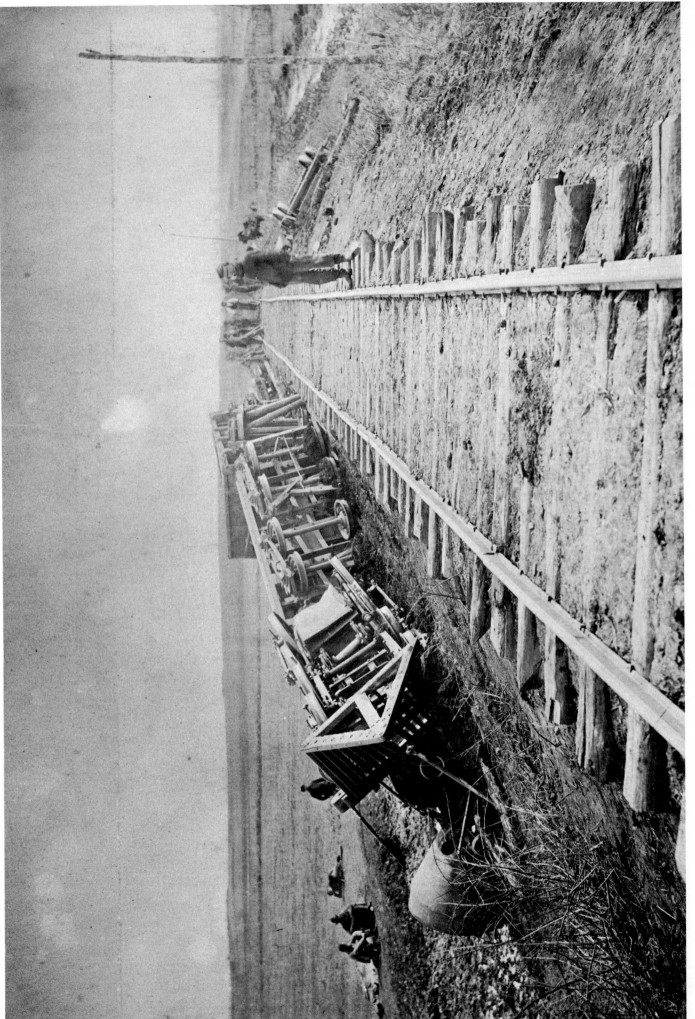

13. Engine *Government* down the "Banks," near Brandy; April 1864.
[No. 133.]

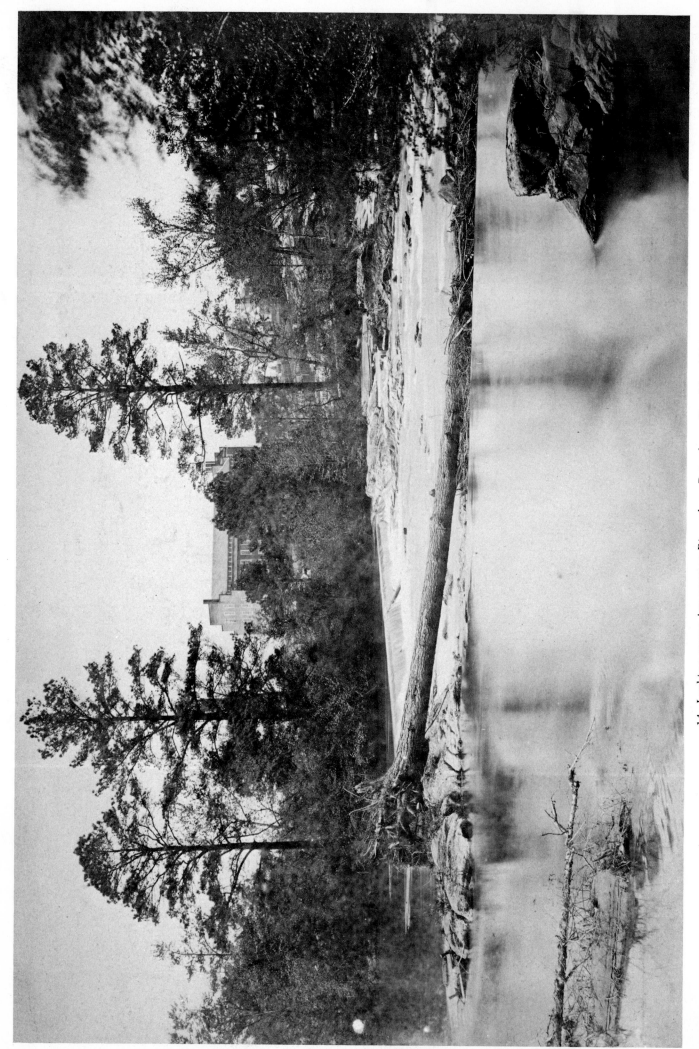

14. Looking across Appomattox River above Petersburg, Va.; May 1864.

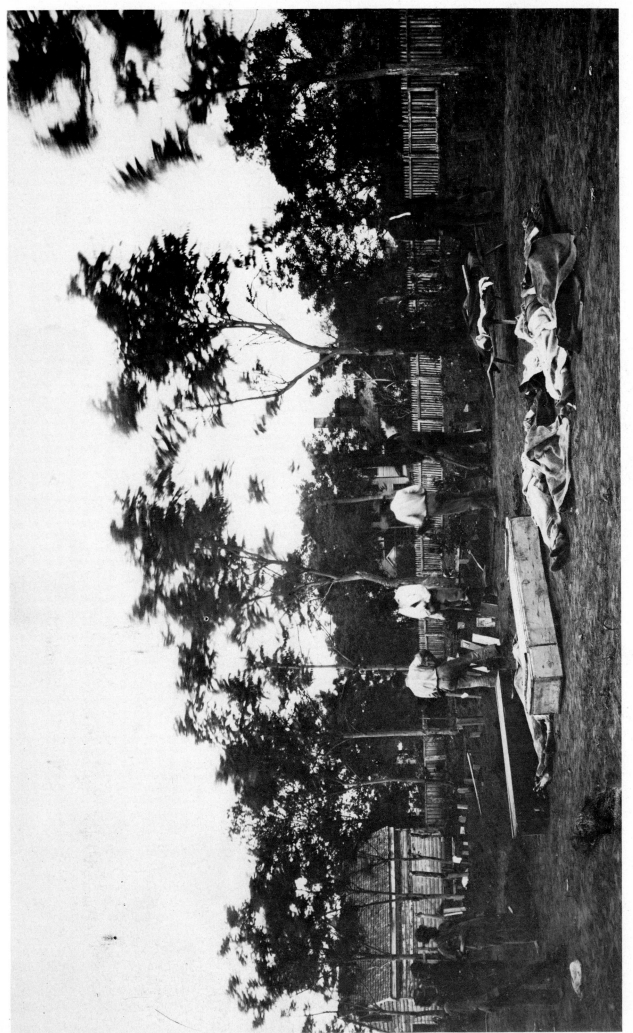

15. Burying the dead, Fredericksburg; casualties of the battles of the Wilderness and Spotsylvania Court House; May 12, 1864. [No. 96.]

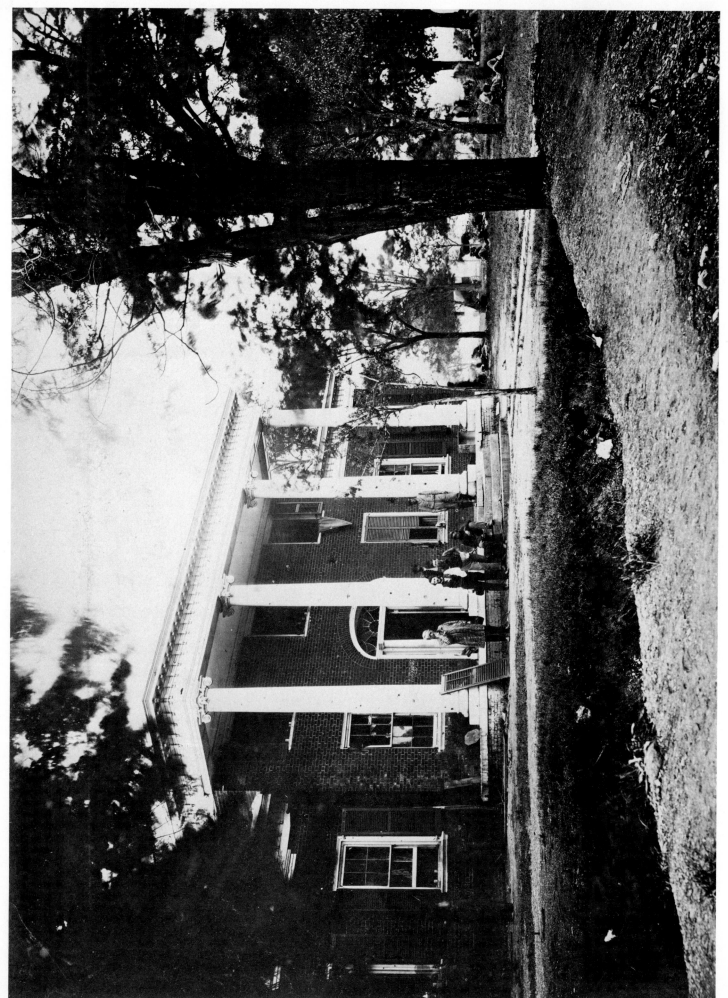

16. Marye's house, Marye's Heights, Fredericksburg, used as a hospital; May 15, 1864. [No. 117.]

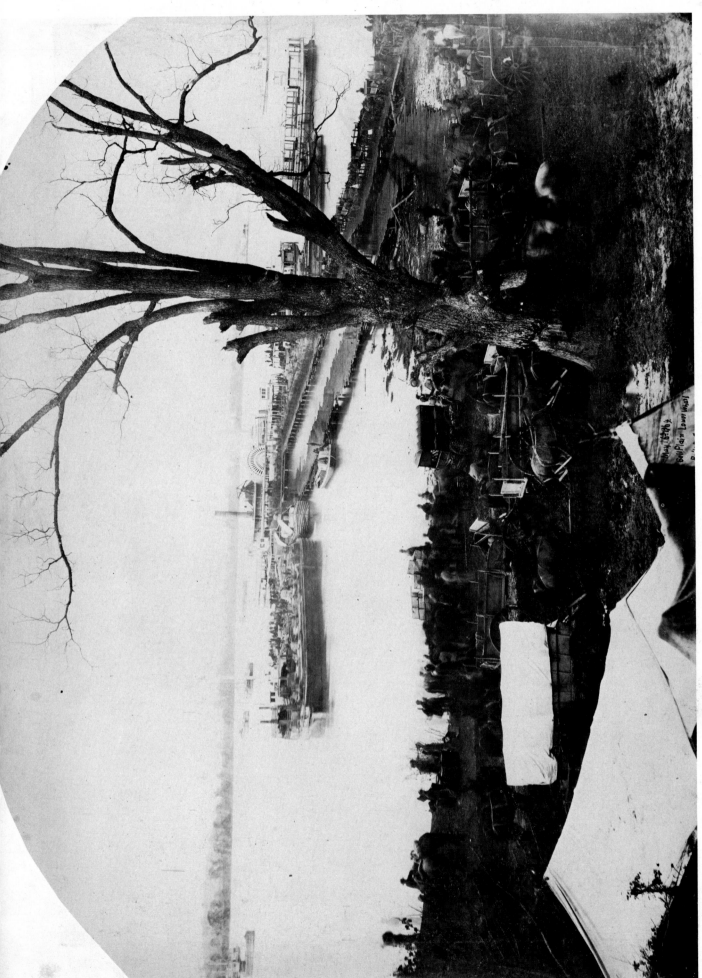

17. Belle Plain, Va.; base of supplies for the Army of the Potomac; May 16, 1864. [No. 113; original printed caption had "May 10."]

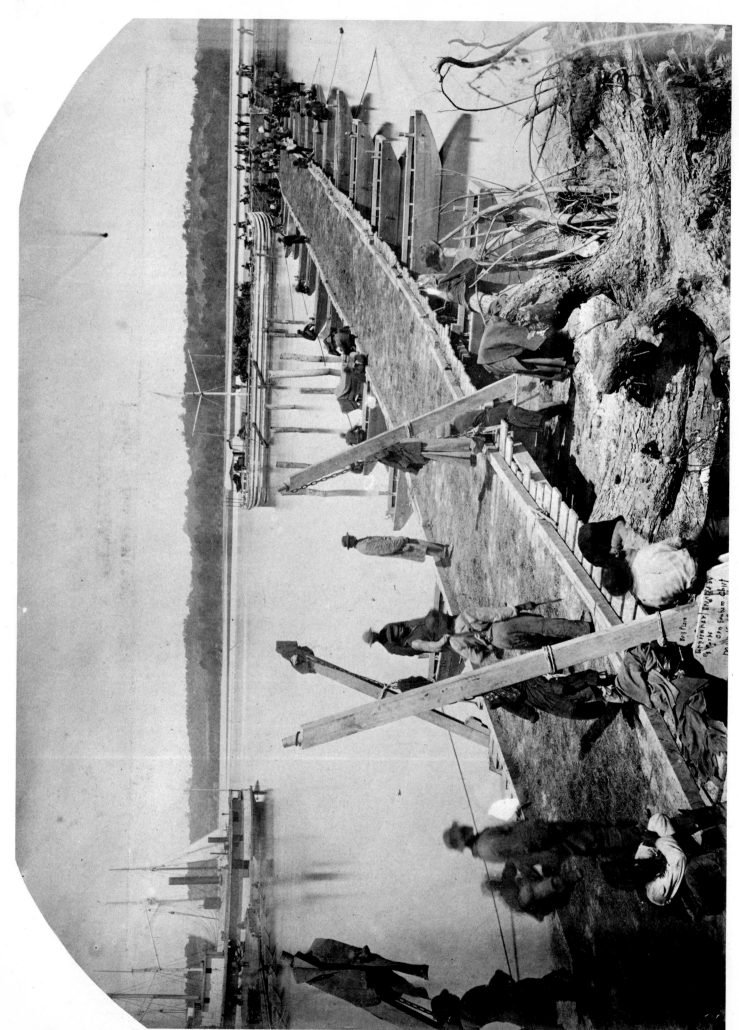

18. Upper wharf, Belle Plain, laid by the Engineer Corps; May 16, 1864.
[No. 189.]

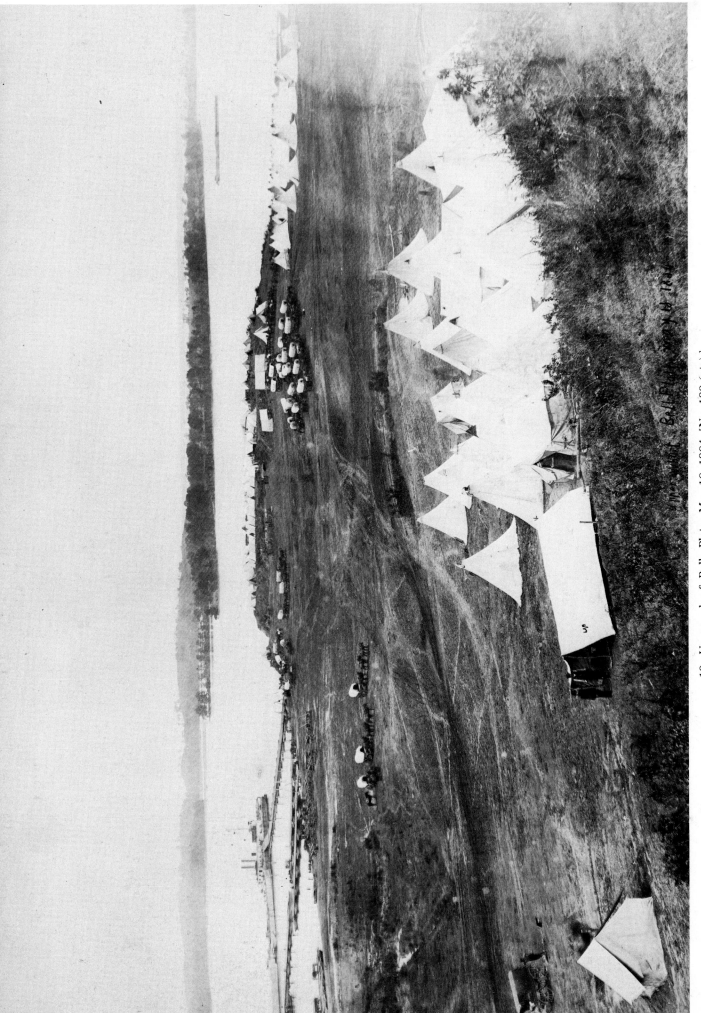

19. Upper wharf, Belle Plain; May 16, 1864. [No. 189 (*sic*).]

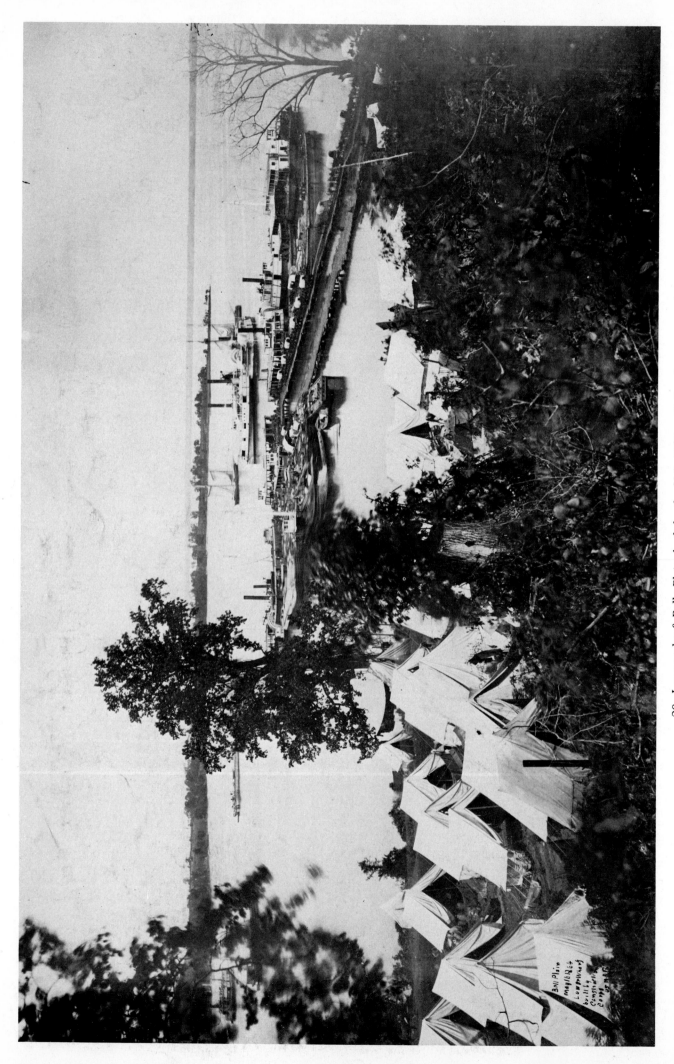

20. Lower wharf, Belle Plain, built by the U.S. Military Railroad Construction Corps; May 16, 1864. [No. 165.]

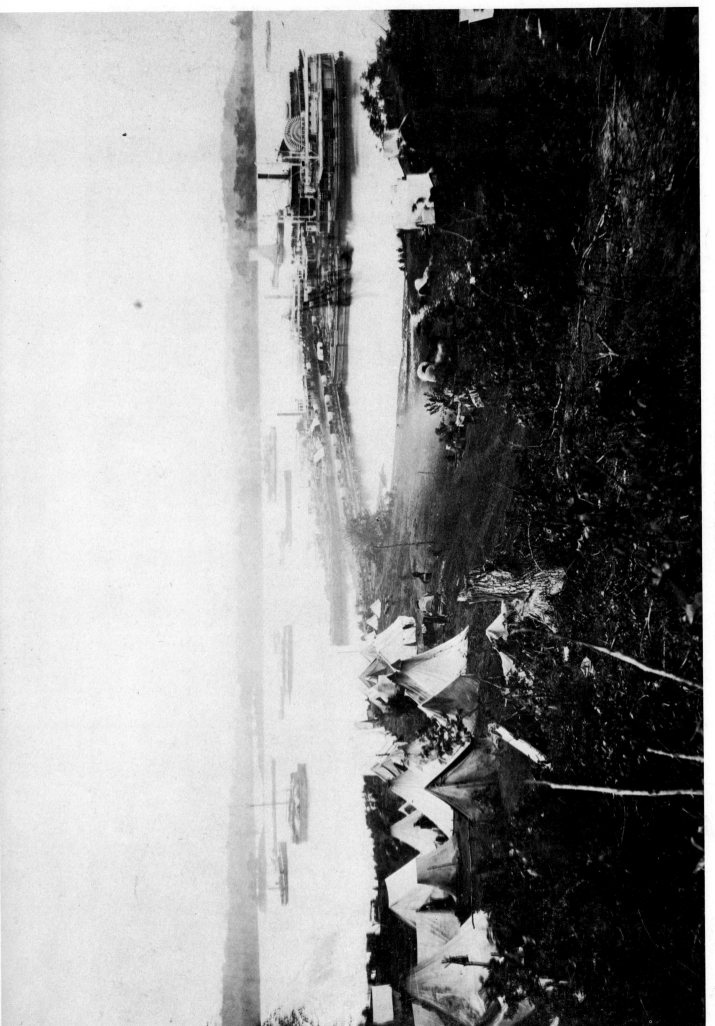

21. Lower wharf, Belle Plain. [No. 165 (*sic*).]

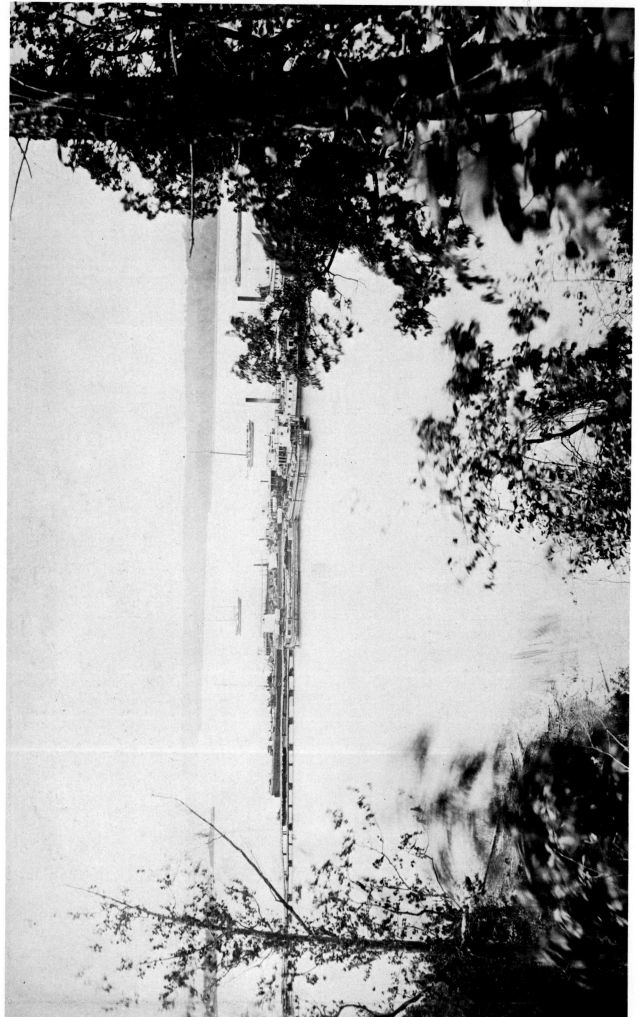

22. Belle Plain; May 18, 1864. [No. 116.]

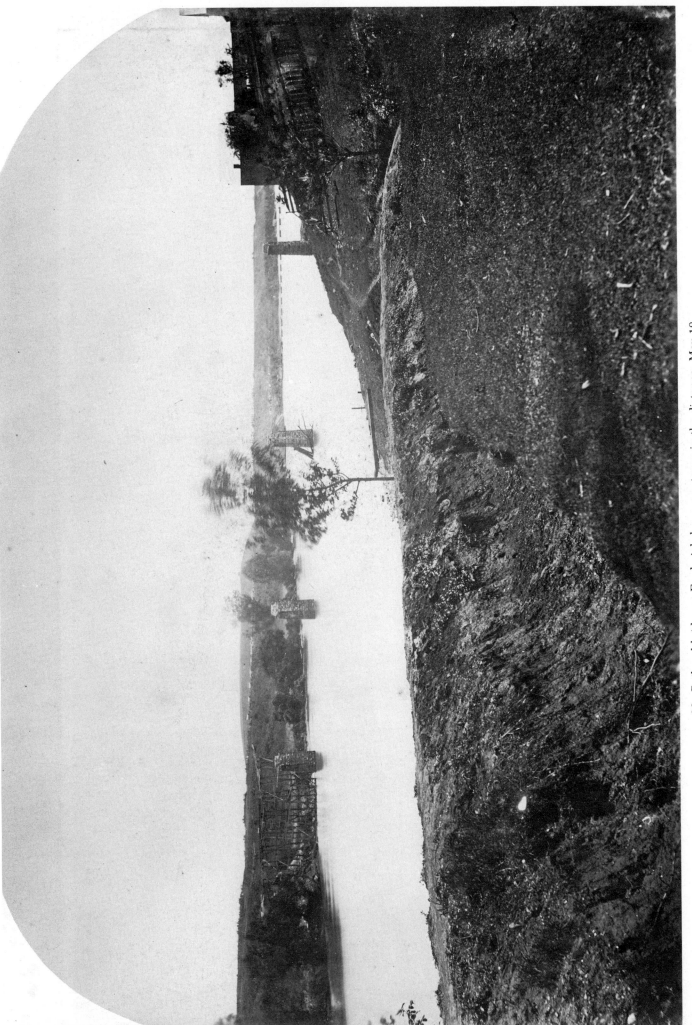

23. Railroad bridge at Fredericksburg; pontoons in the distance; May 18, 1864. [No. 190.]

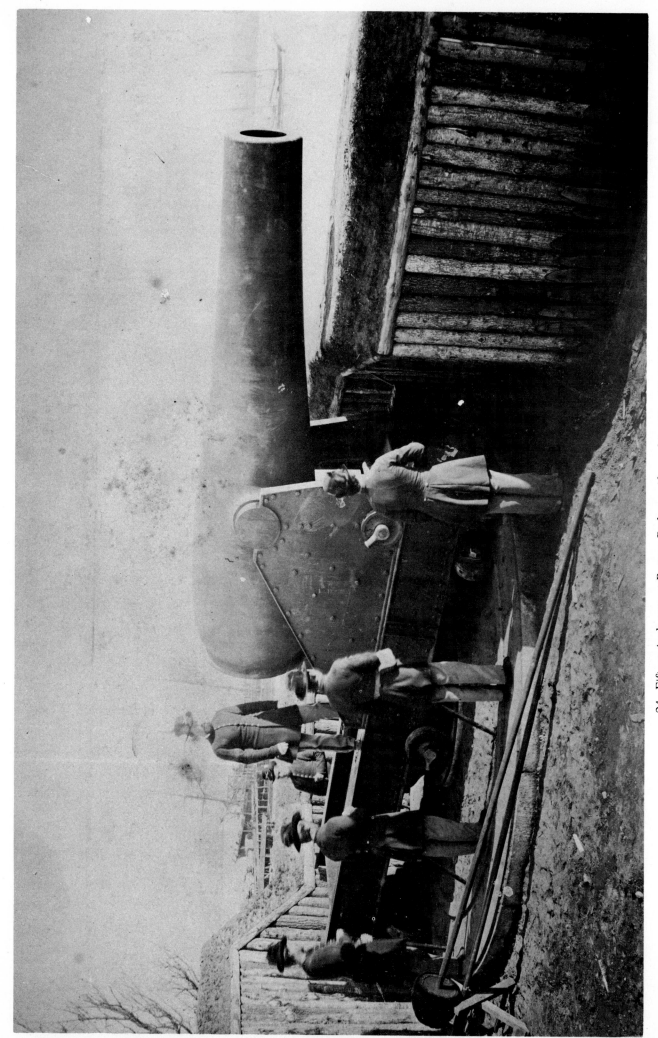

24. Fifteen-inch gun at Battery Rodgers, Alexandria; May 18, 1864.
[No. 246.]

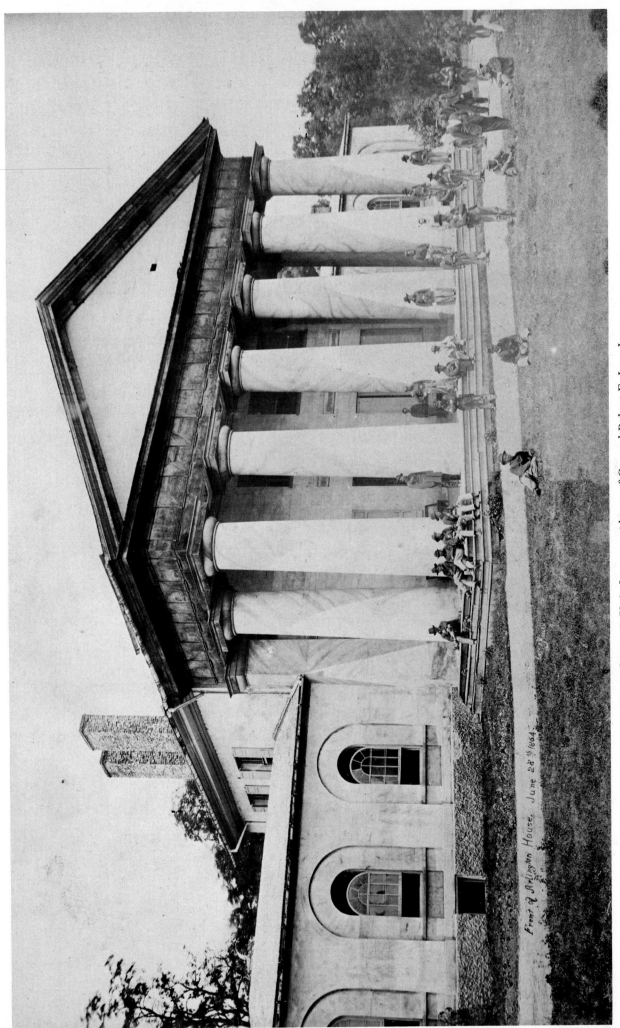

Front of Arlington House. June 28th 1864.

25. "Arlington" (Va.), former residence of General Robert E. Lee; June 28, 1864. [No. 111.]

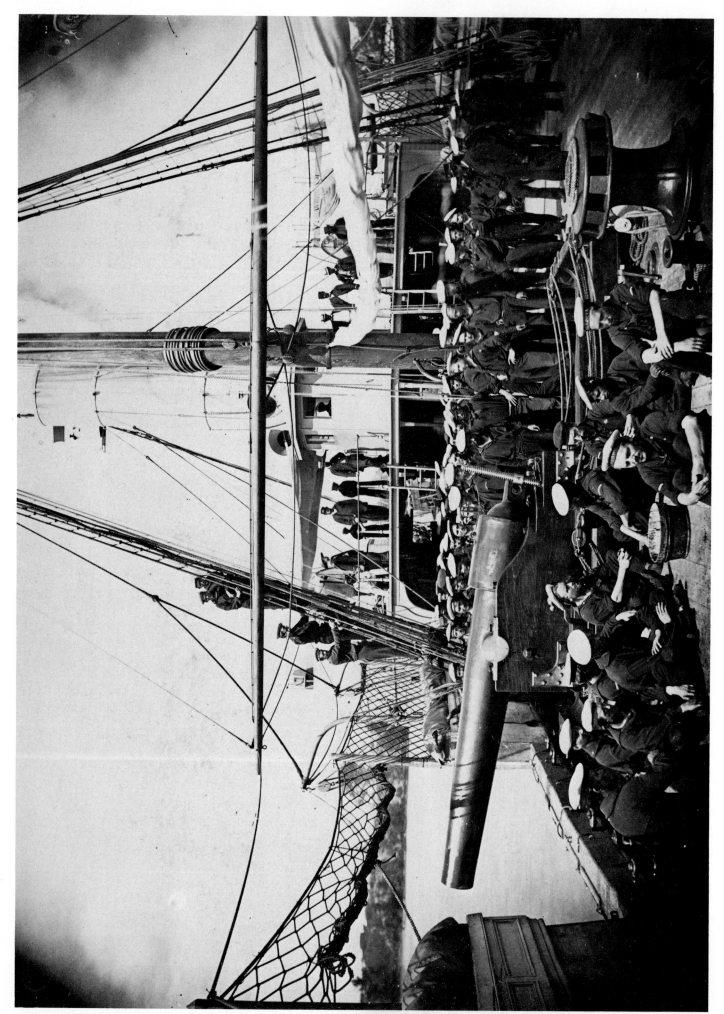

26. Officers and crew of the gunboat *Mendota*, James River, *Va.*; July 18, 1864. [No. 148; original caption called the boat *Agawam*.]

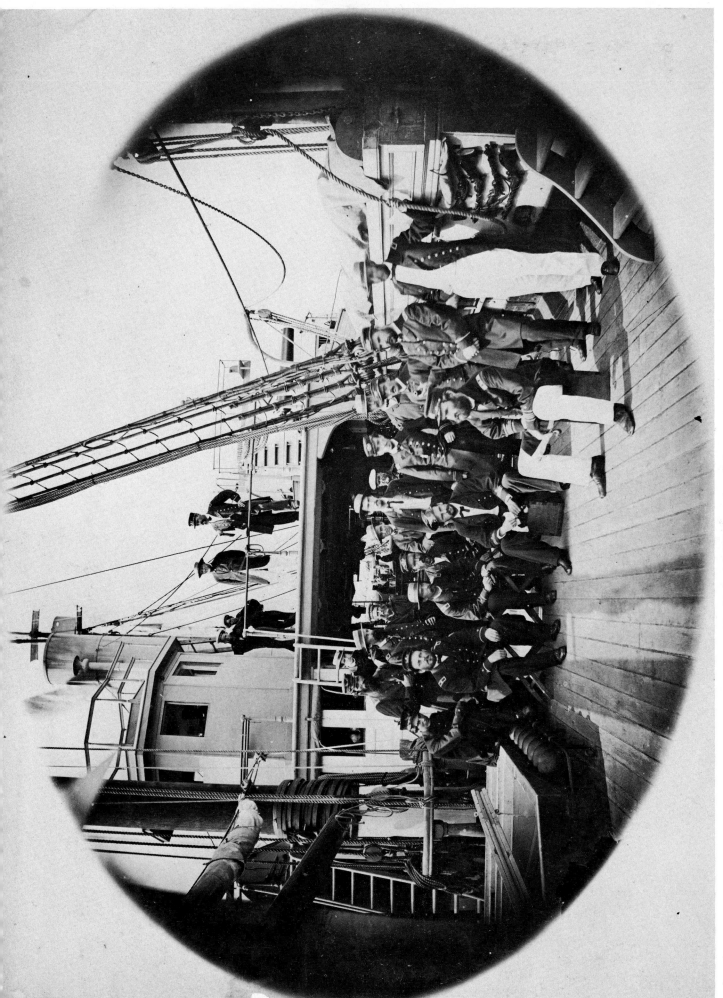

27. Group of officers on board the *Mendota*.

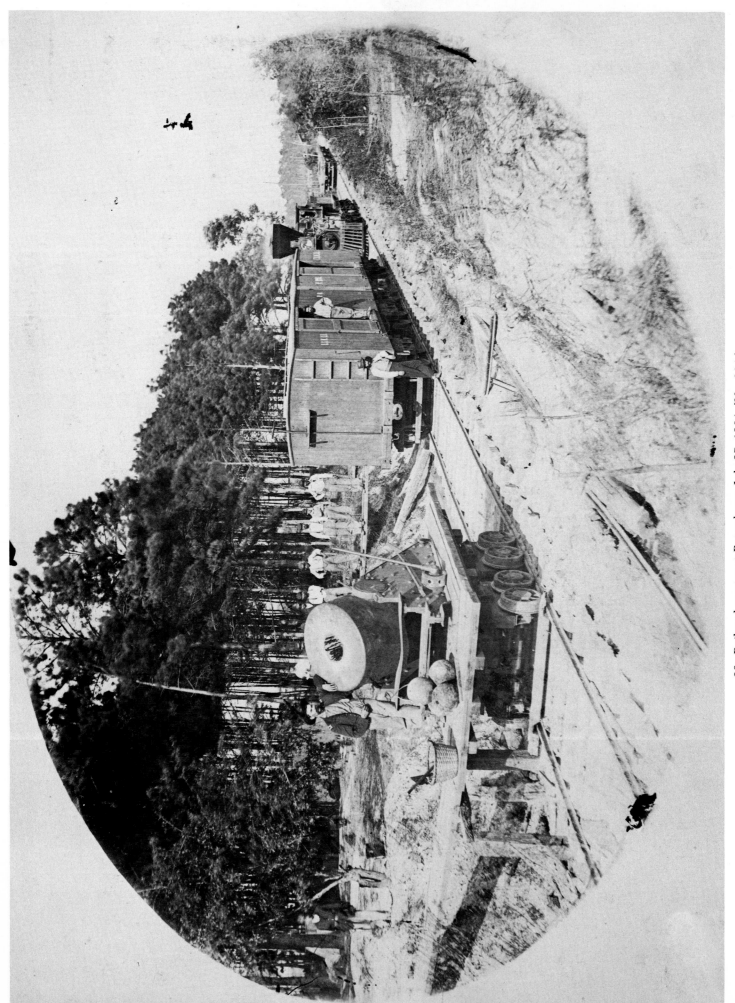

28. Railroad mortar at Petersburg; July 25, 1864. [No. 304.]

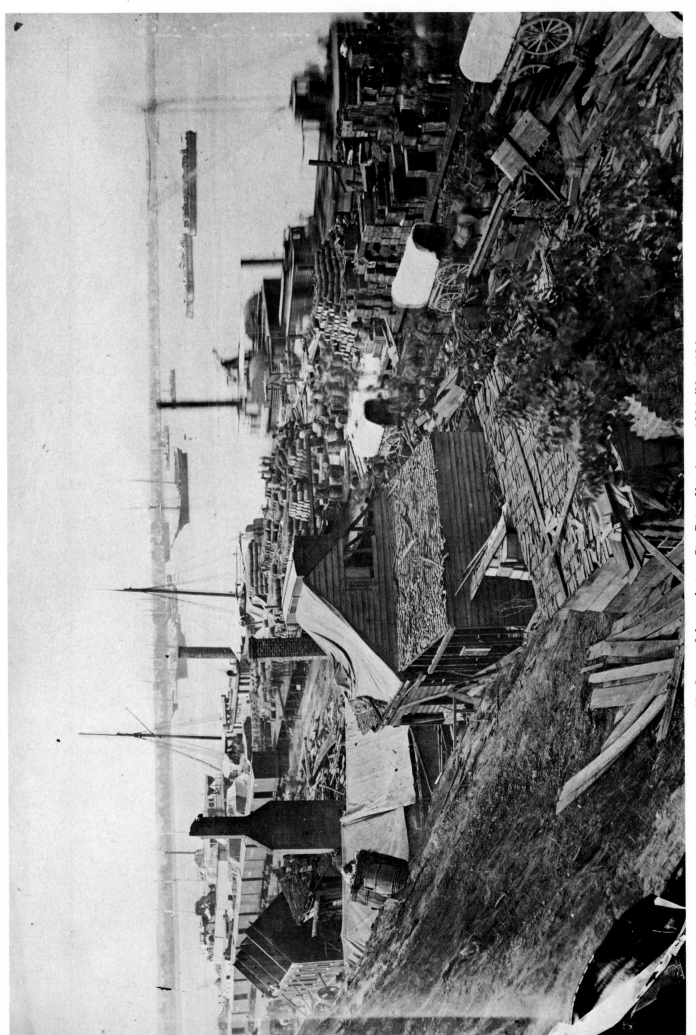

29. Scene of the explosion, City Point, Va.; August 1864. [No. 108.]

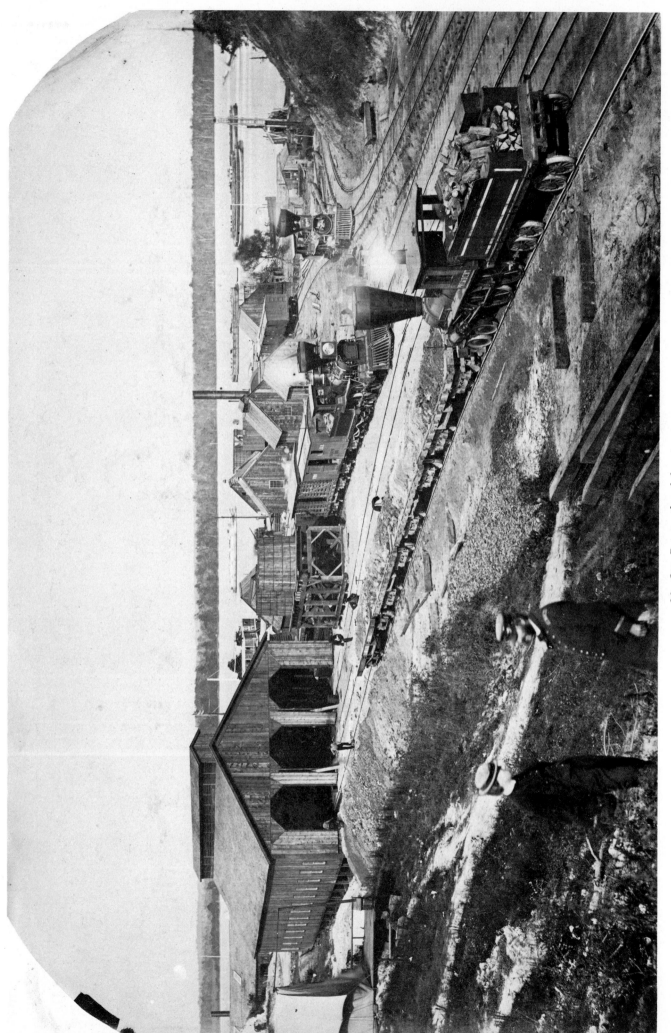

30. City Point railroad depot.

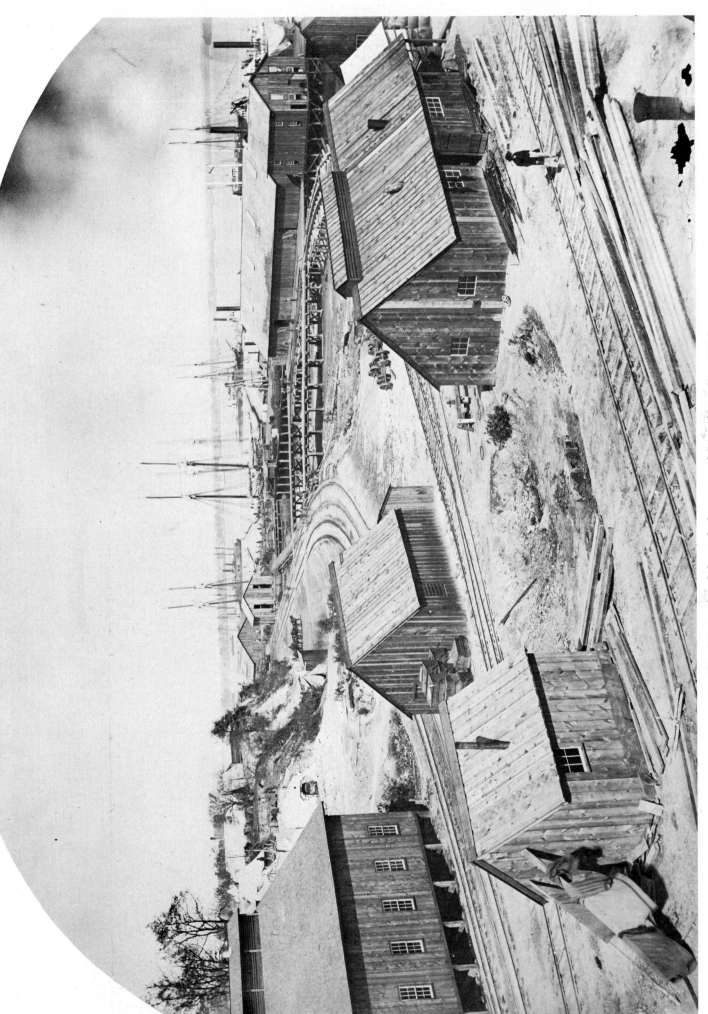

31. City Point railroad depot, looking toward Petersburg. [No. 144.]

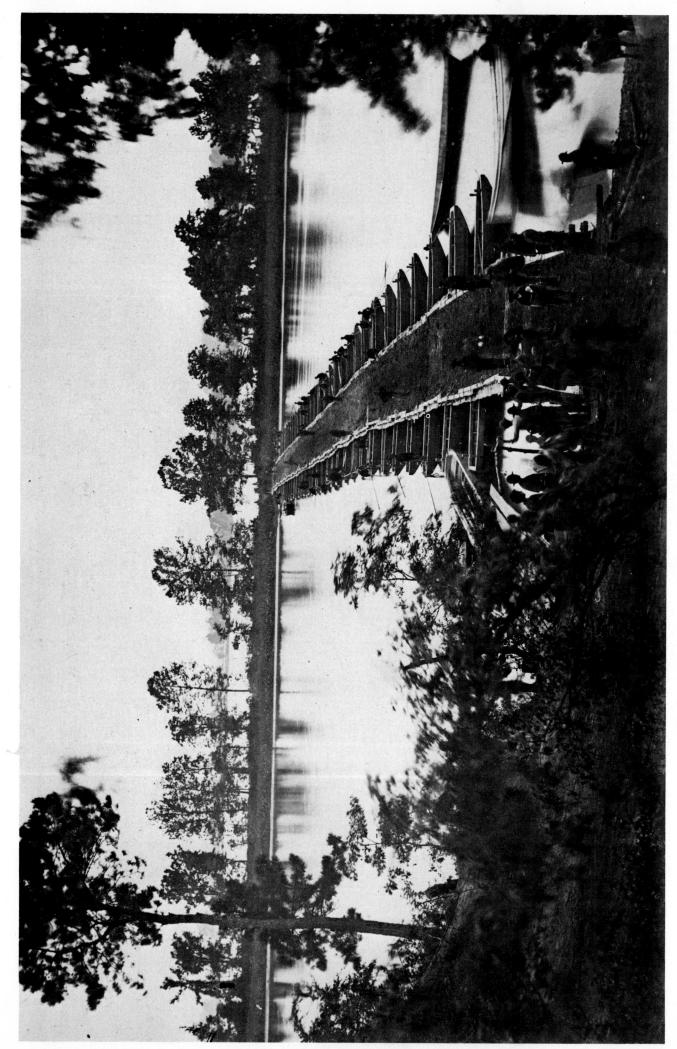

32. Pontoon bridge across the James River at Deep Bottom; September 1, 1864. [No. 37.]

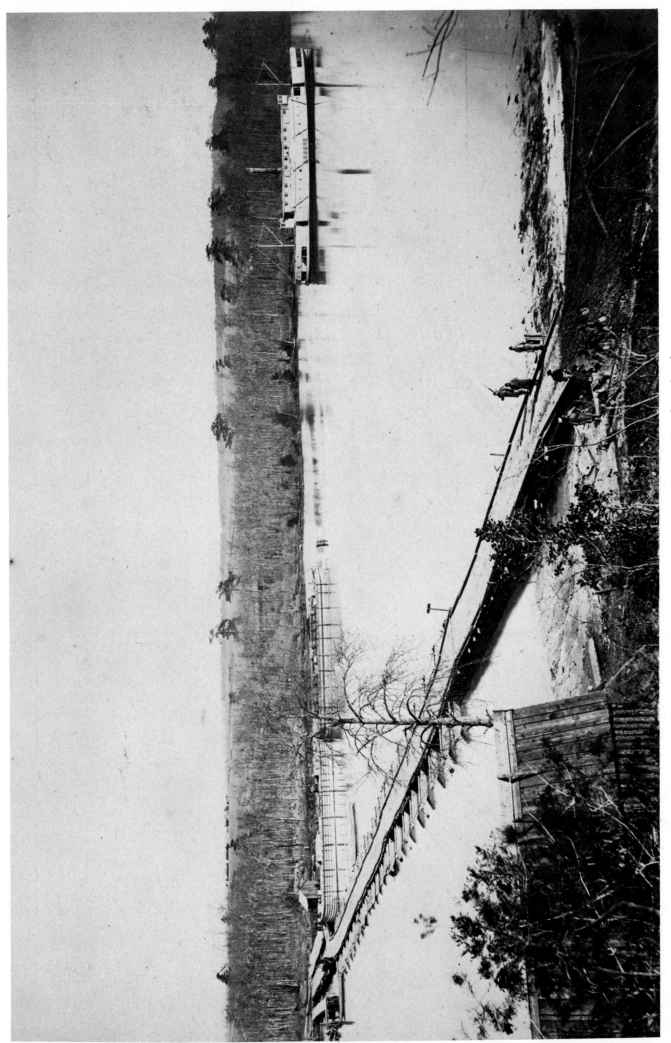

33. Pontoon bridge across the Appomattox River at Broadway Landing; December 4, 1864.

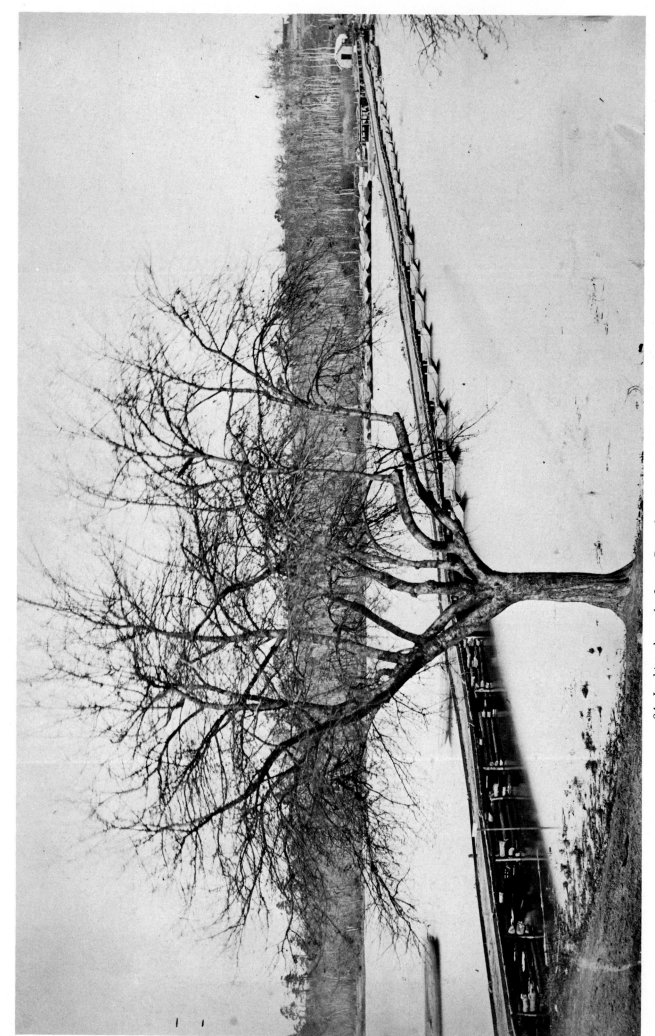

34. Looking down the James River from Dutch Gap Canal; December 12, 1864.

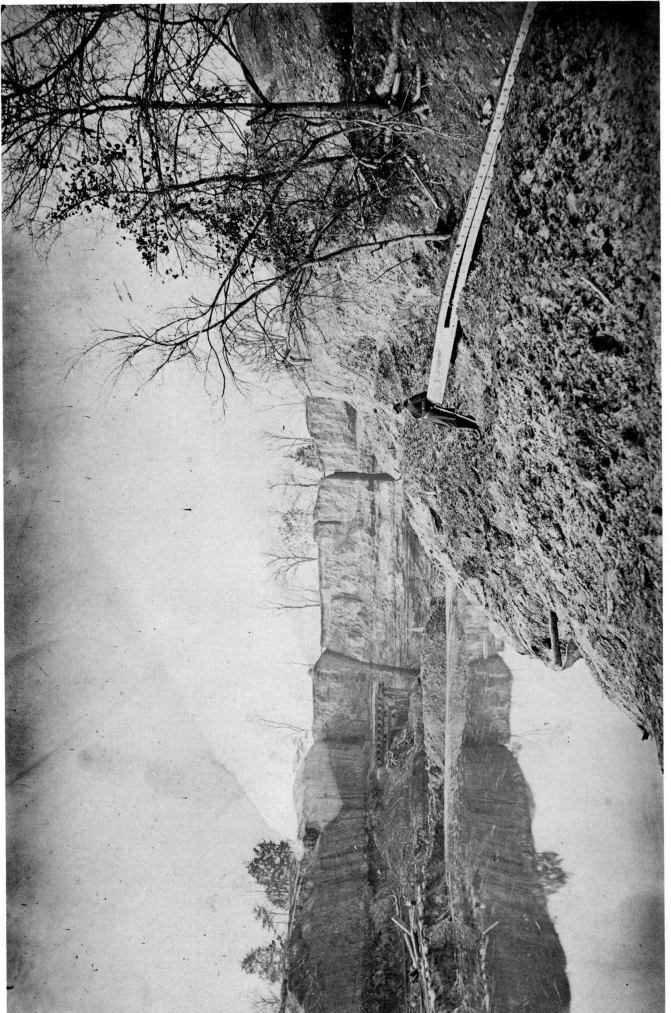

35. Dutch Gap Canal; January 1865.

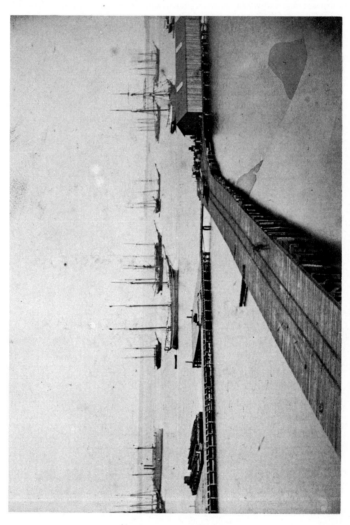

36. Magazine wharf, City Point; January 1865.

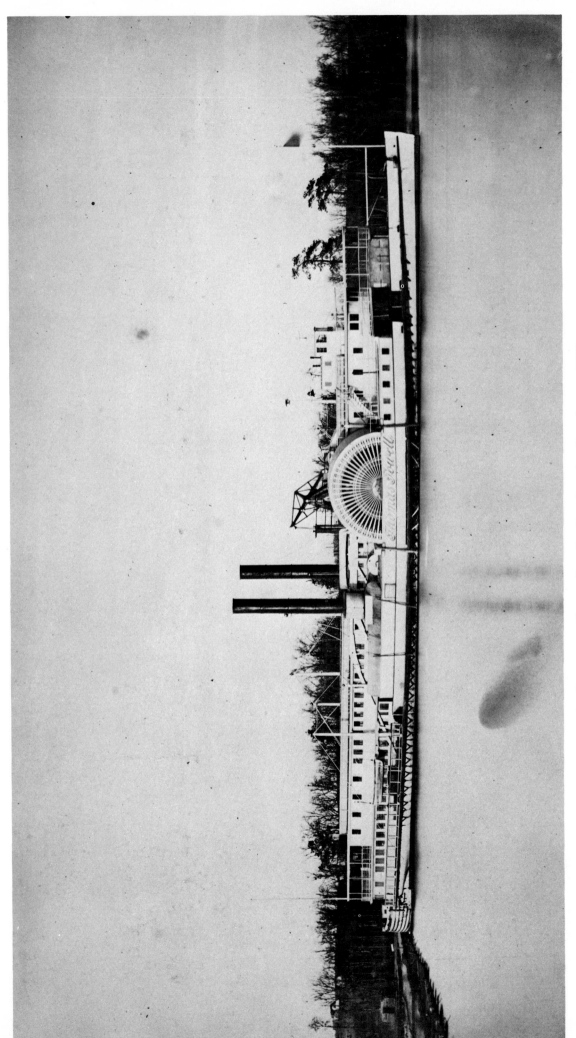

37. The steamer *Thomas Powell* at Broadway Landing; January 1865.

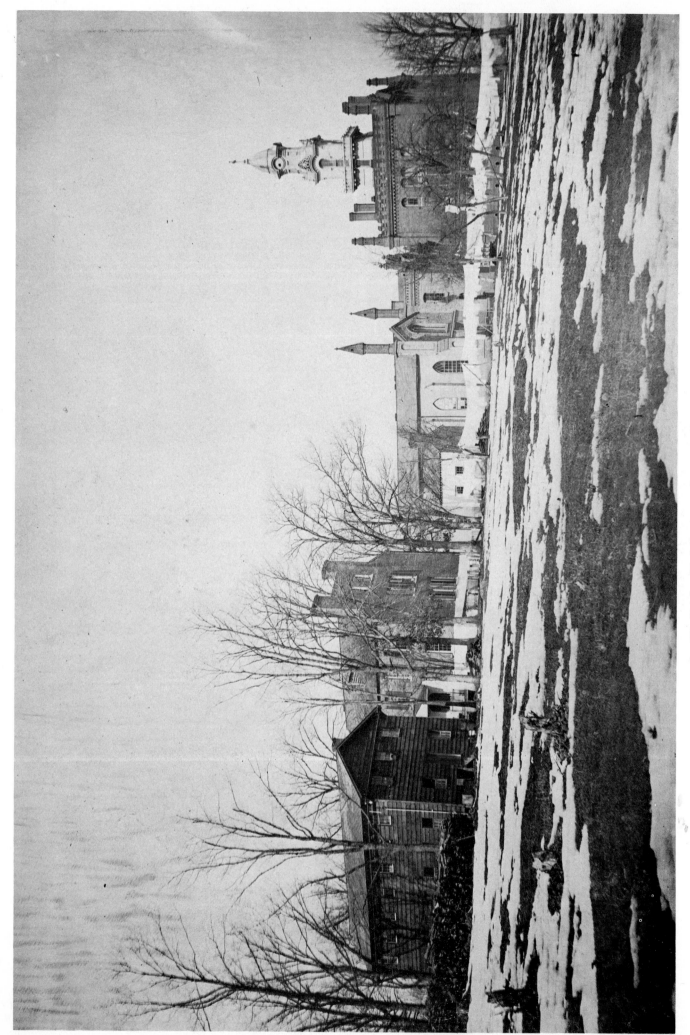

38. Fairfax (Va.) Seminary; January 1865.

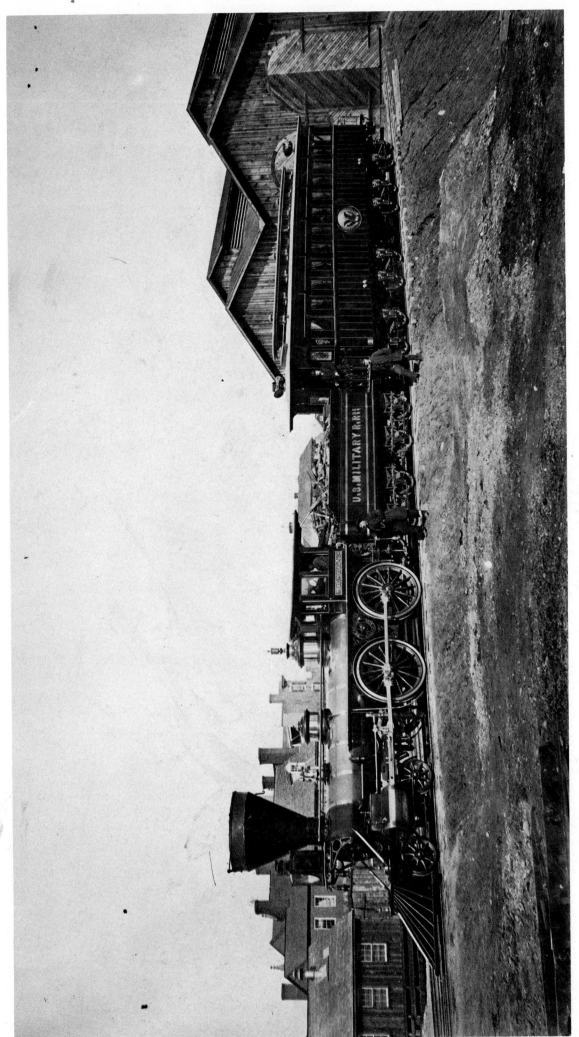

39. The engine *W. H. Whiton* and the President's car; January 1865.

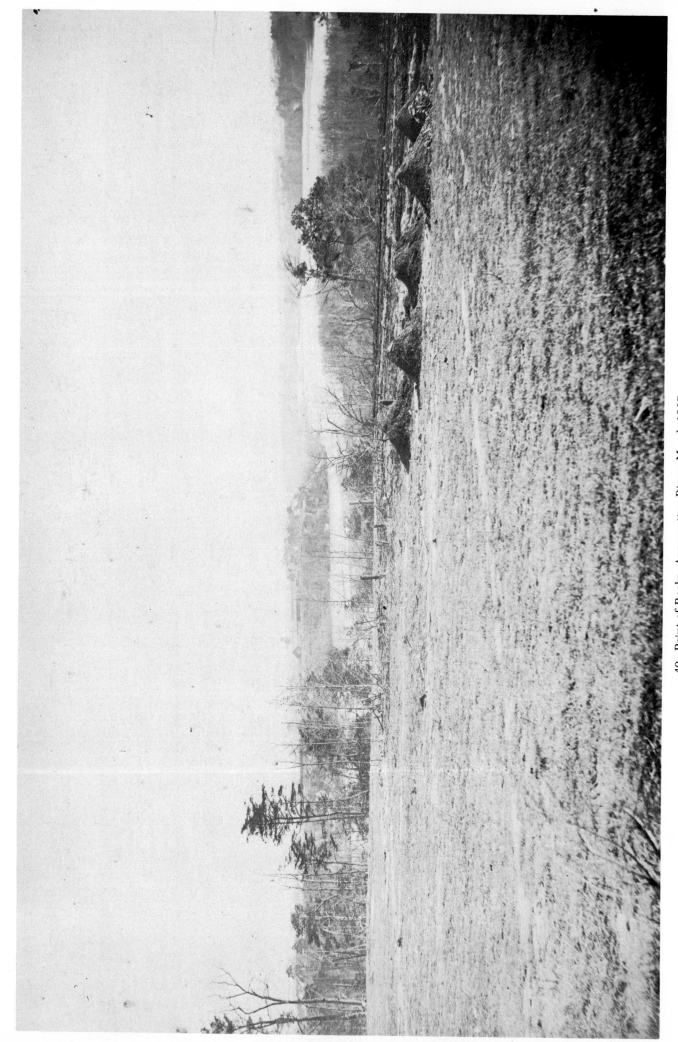

40. Point of Rocks, Appomattox River; March 1865.

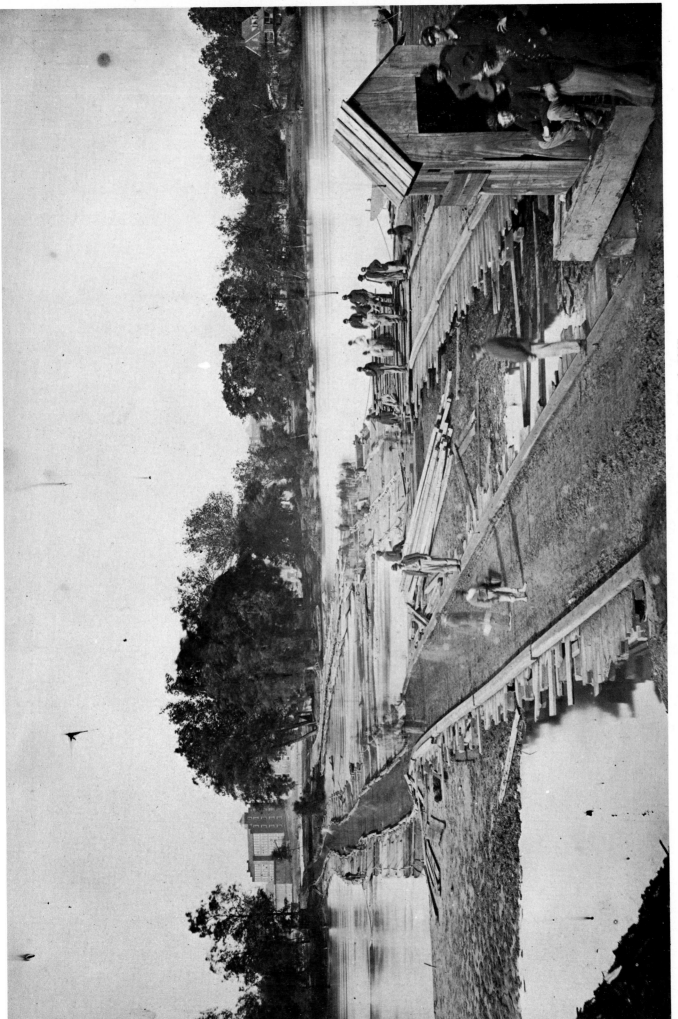

41. Bridge built by the Engineer Corps, James River; March 1865.

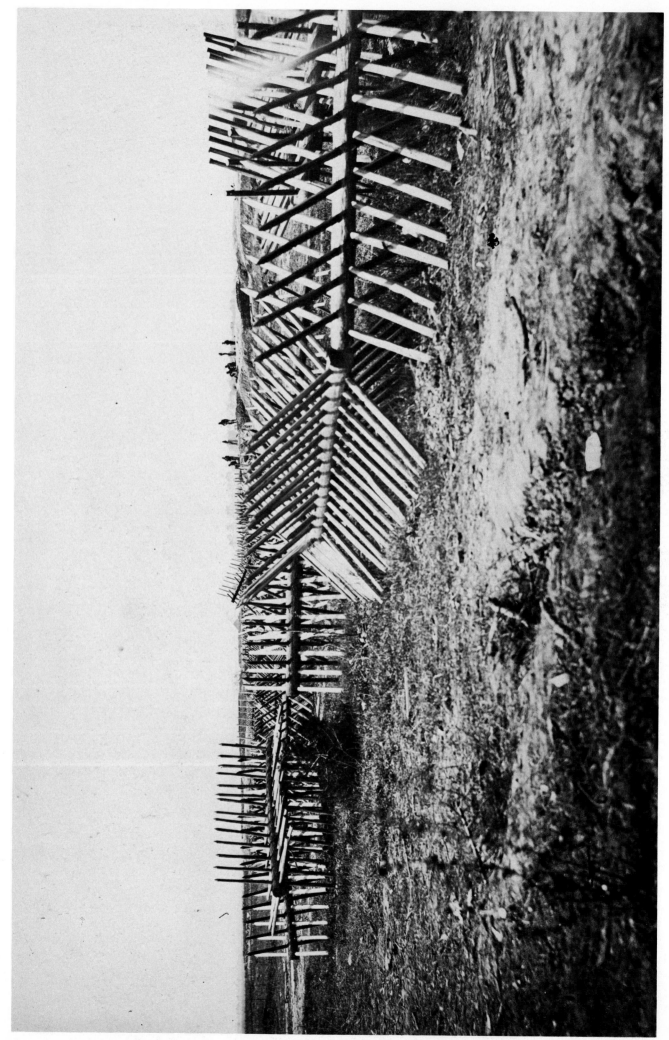

42. Cheval-de-frise in front of Fort Mahone ("Fort Damnation"); April 1865.

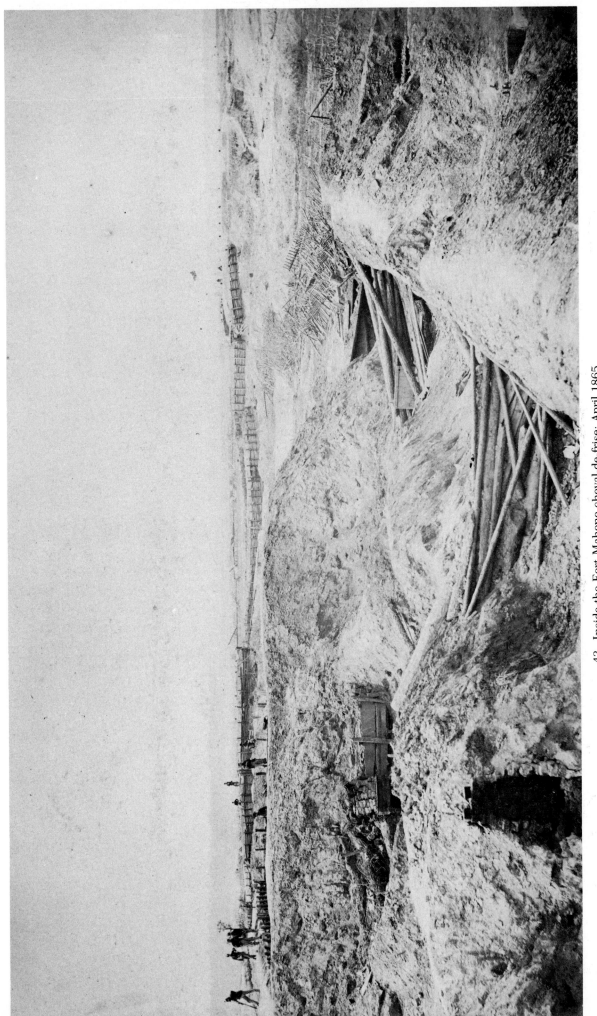

43. Inside the Fort Mahone cheval-de-frise; April 1865.

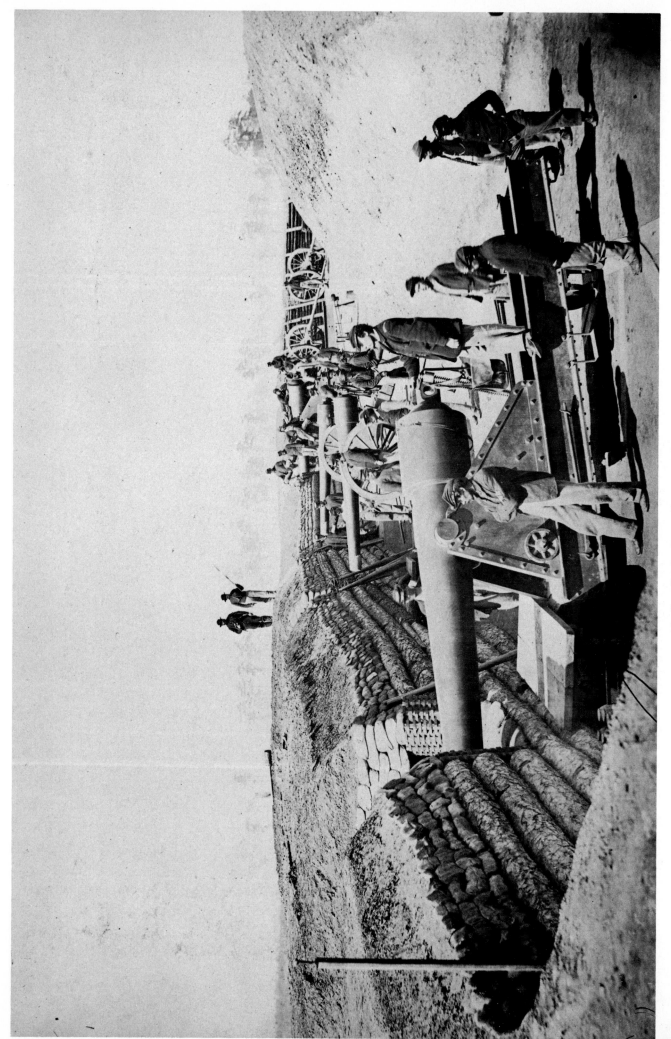

44. Fort Brady, James River; April 1865.

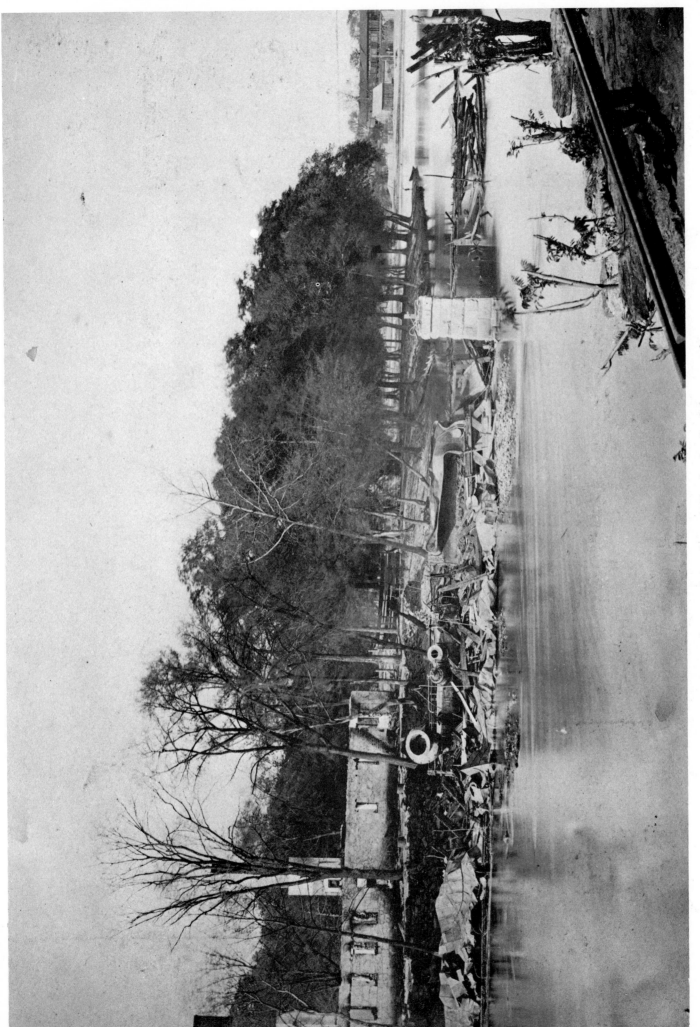

45. Ruins of engines burned on a bridge by the Confederates at the evacuation of Petersburg; April 1865.

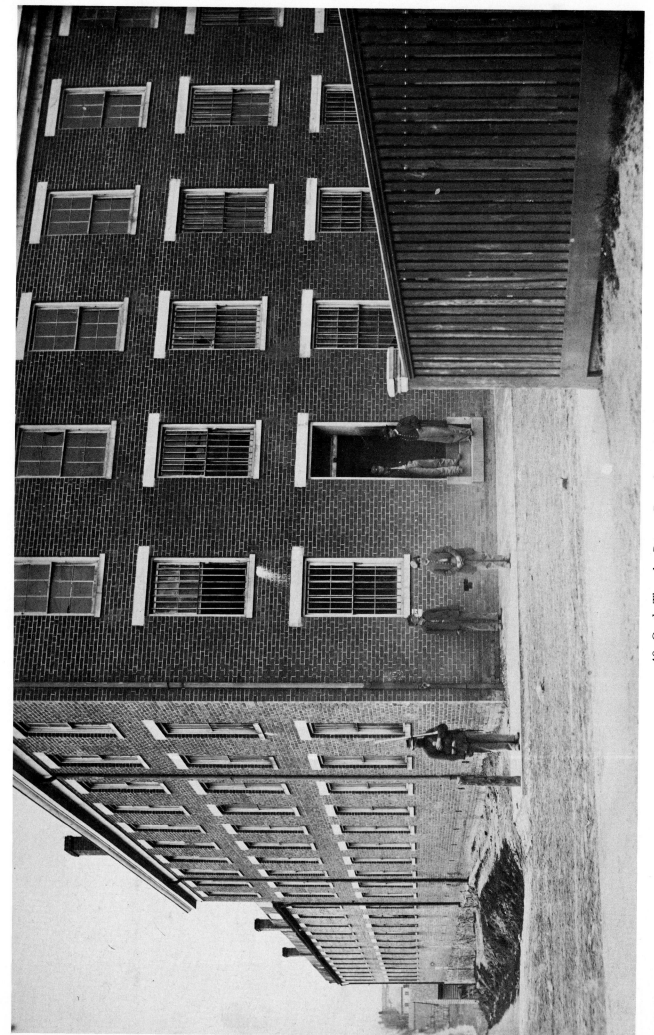

46. Castle Thunder Prison, Petersburg; April 1865.

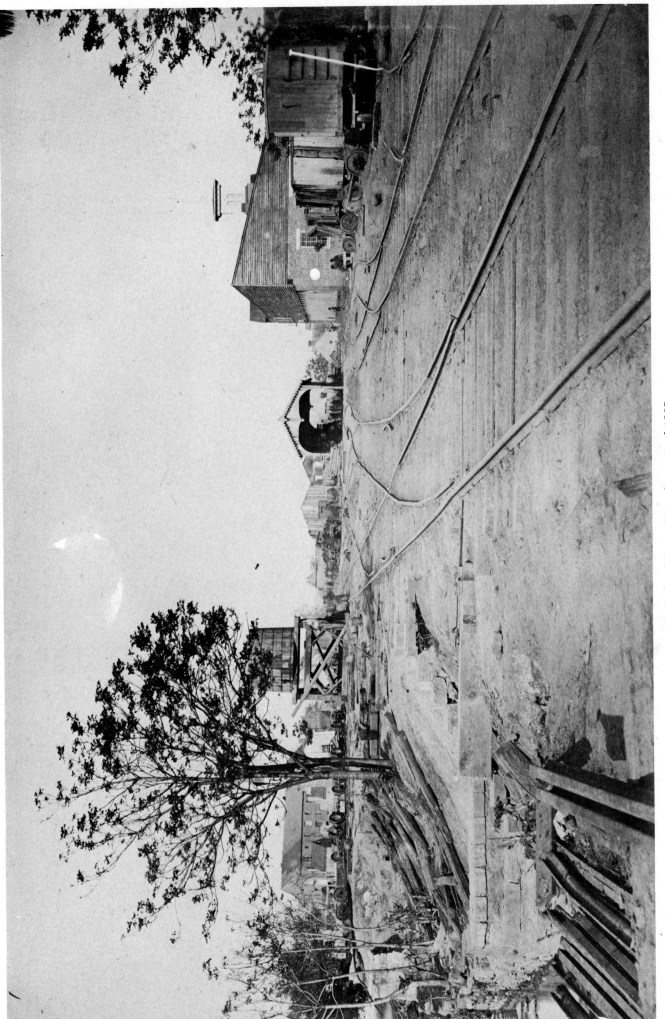

47. Railroad depot, Petersburg; April 1865.

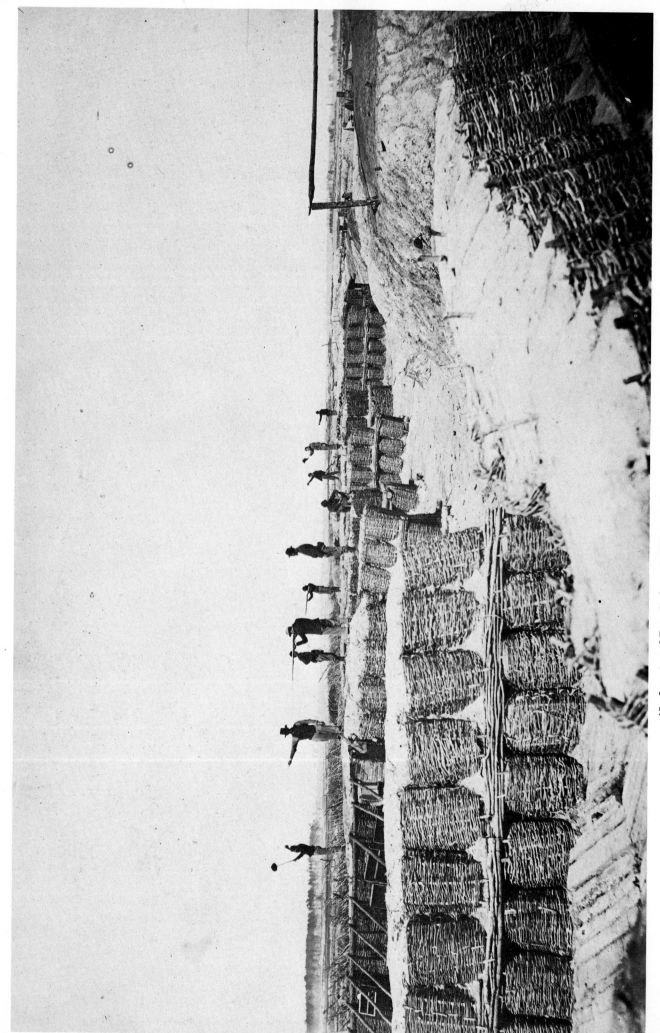

48. Interior of Fort Sedgwick ("Fort Hell") near Petersburg; April 1865.

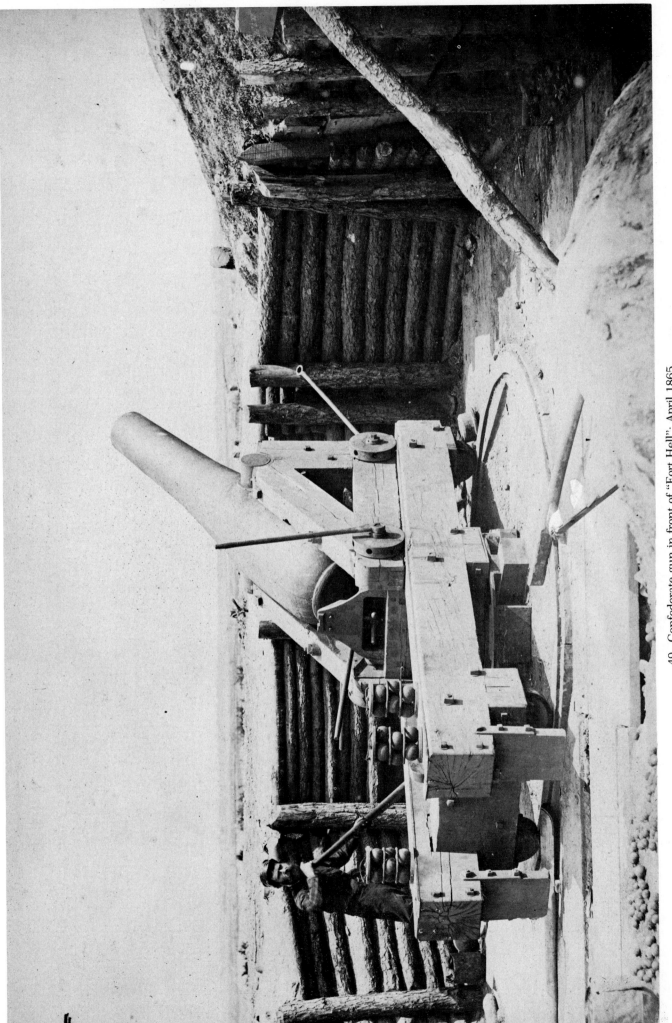

49. Confederate gun in front of "Fort Hell"; April 1865.

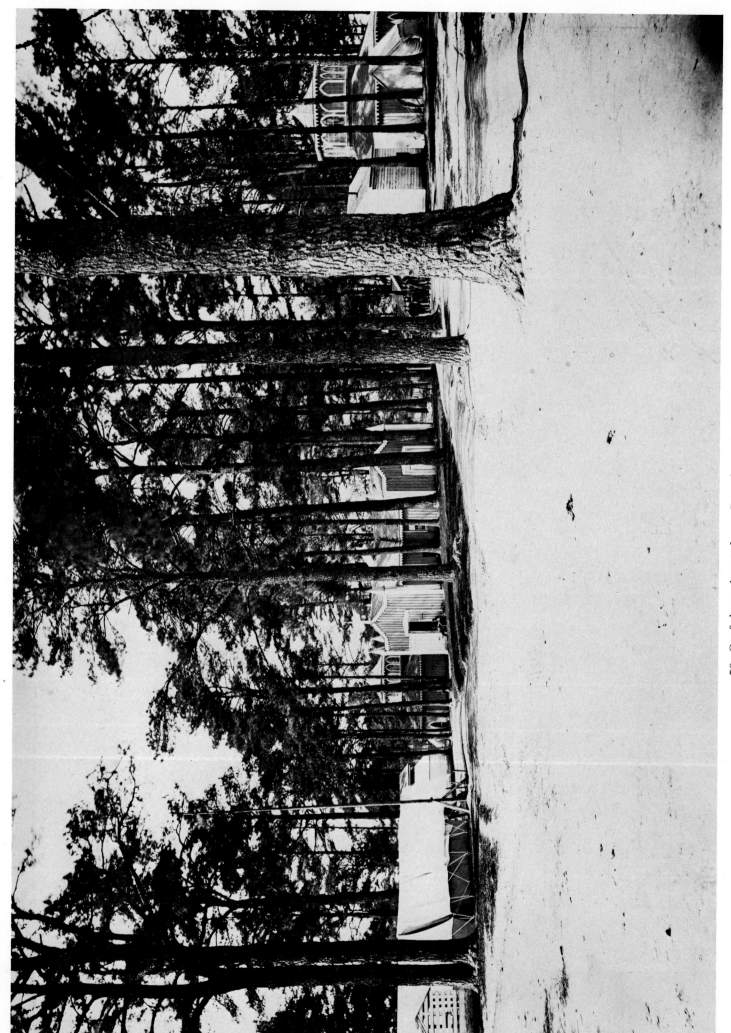

50. Confederate hospital near Petersburg: April 1865.

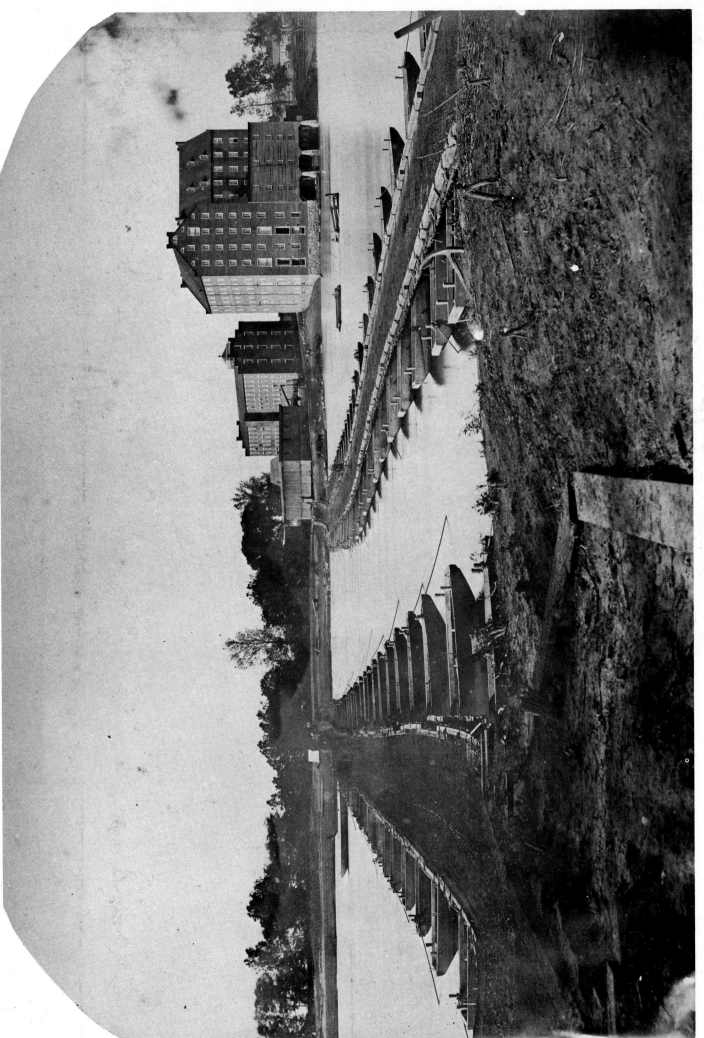

51. Manchester mills, opposite Richmond, Va., with the pontoons crossed by Union forces; April 1865.

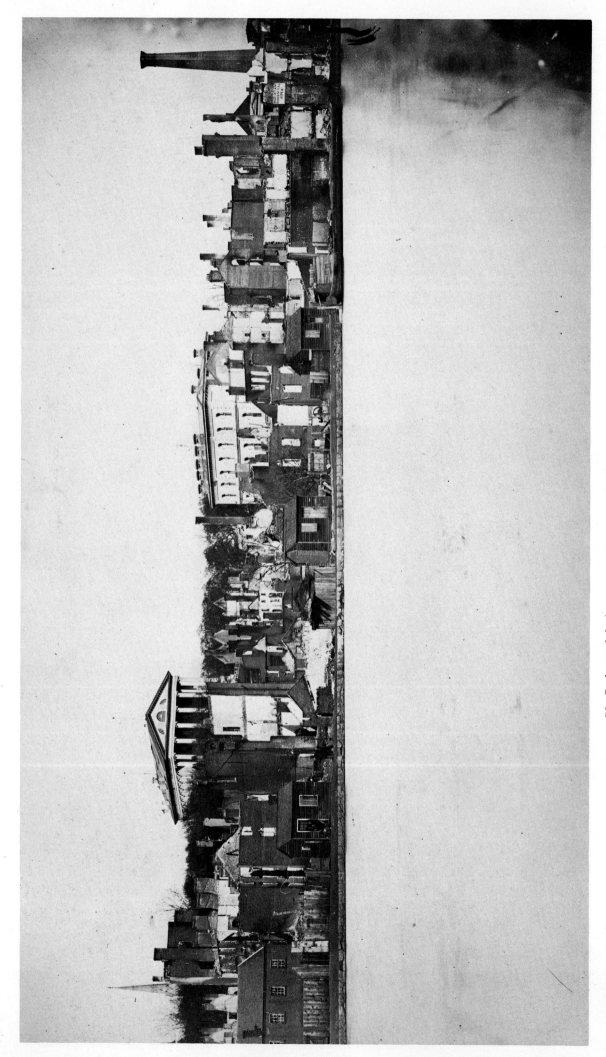

52. Richmond, looking across the Canal Basin; Capitol and Custom House in the distance; April 1865.

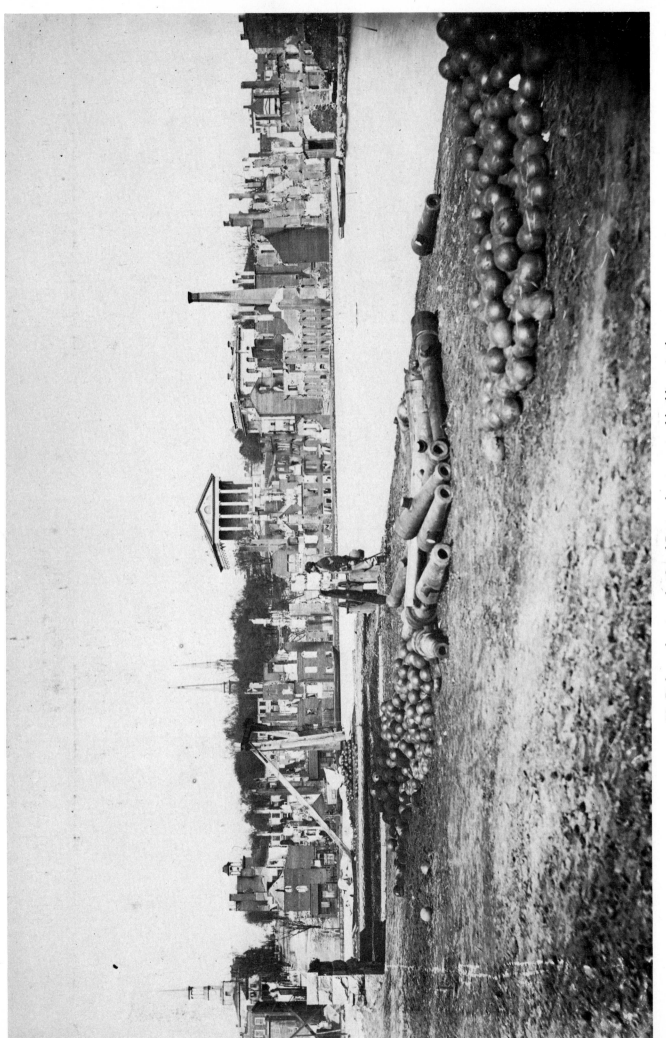

53. Richmond, across the Canal Basin, showing ruined buildings in the distance; April 1865.

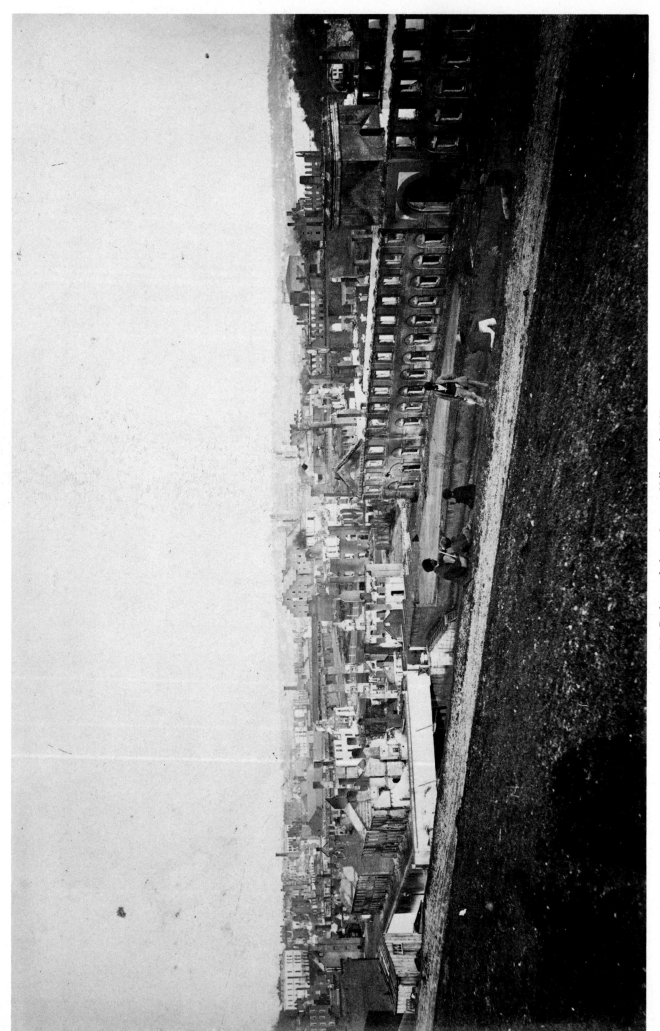

54. Richmond, from Oregon Hill; April 1865.

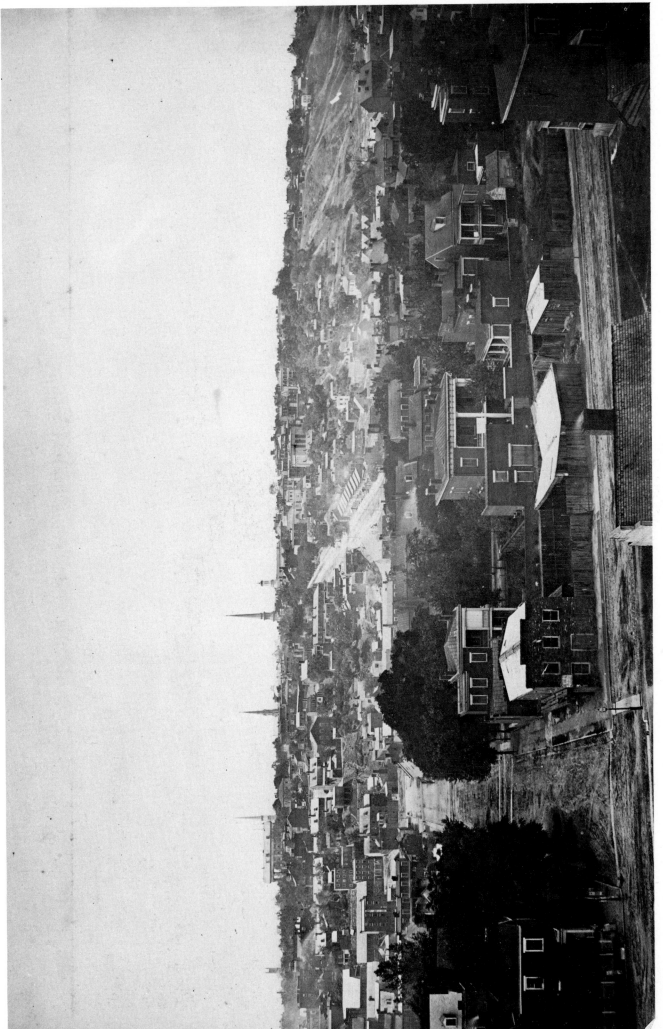

55. Richmond, from Oregon Hill; April 1865.

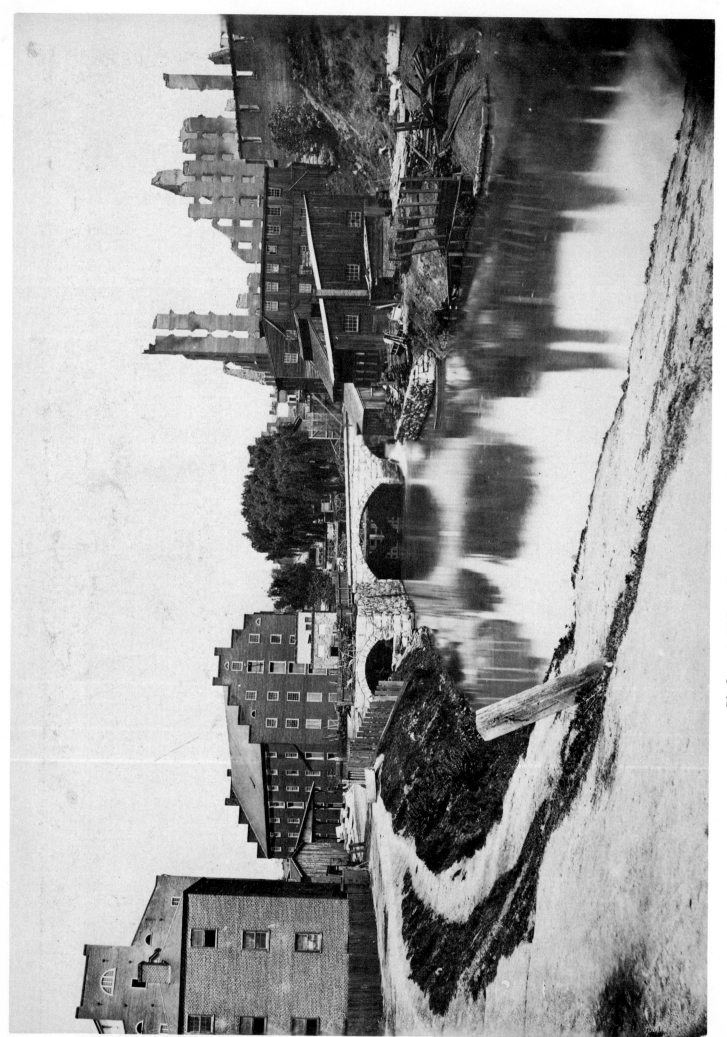

56. Scene in Richmond; ruins of a great flour mill [identified in Meredith, *Mr. Lincoln's Camera Man*, as Cranshaw and Gallego].

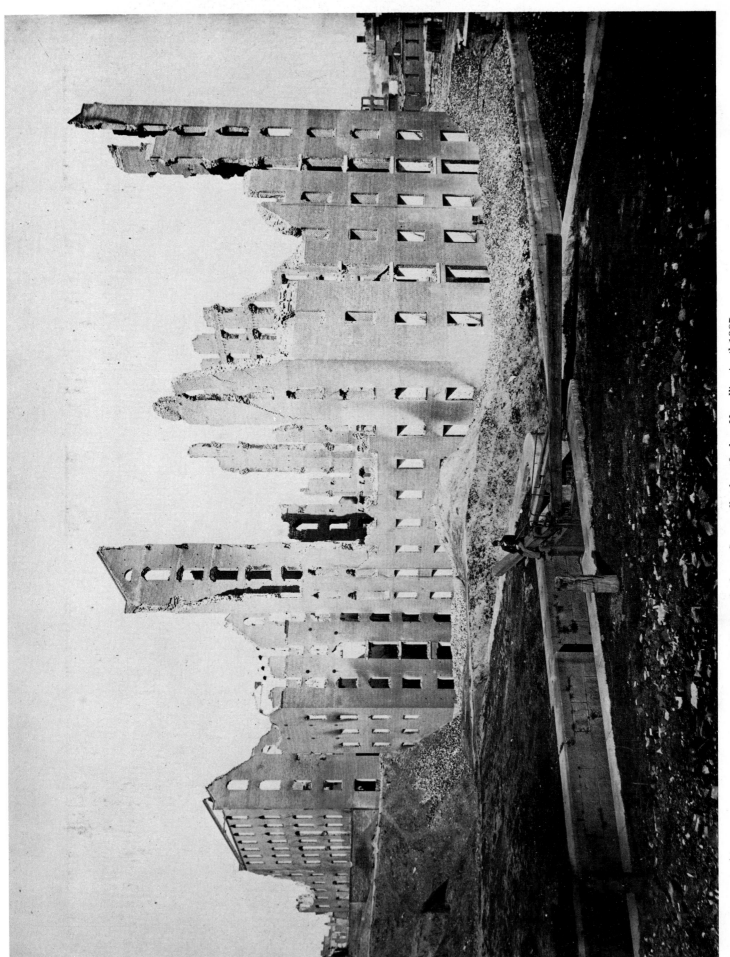

57. Ruins of a large flour mill, identified as Haxall's; April 1865.

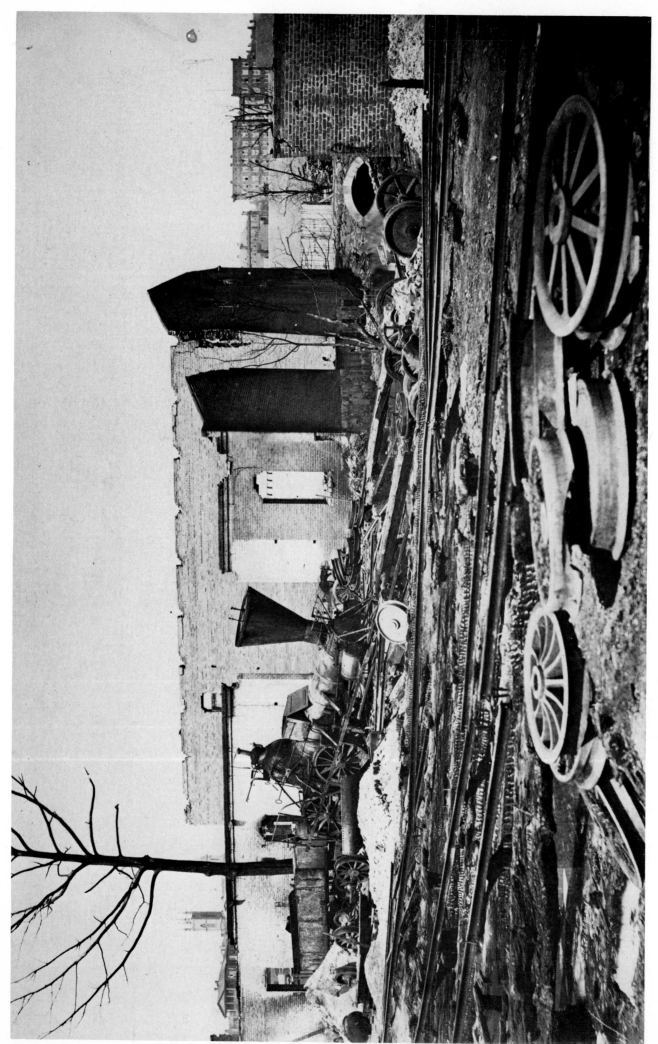

58. Ruins of "P. & R. R." machine shops, Richmond; April 1865.

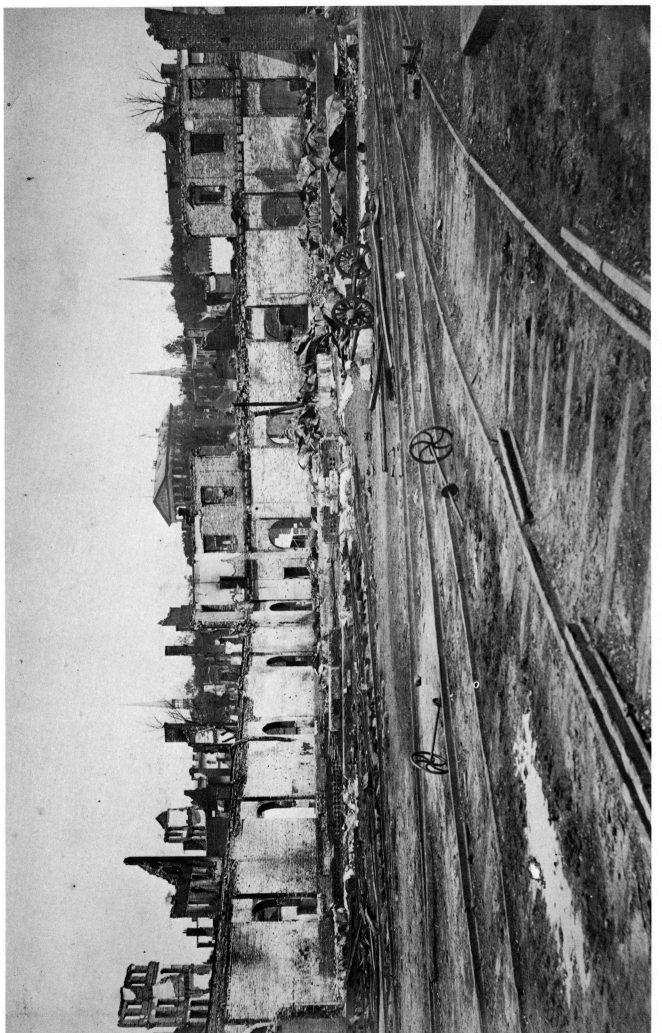

59. Ruins in Richmond; April 1865. [A duplicate of this image in the original album further identifies the site as "Corner of Carey and Governor Streets"; see also plate 66.]

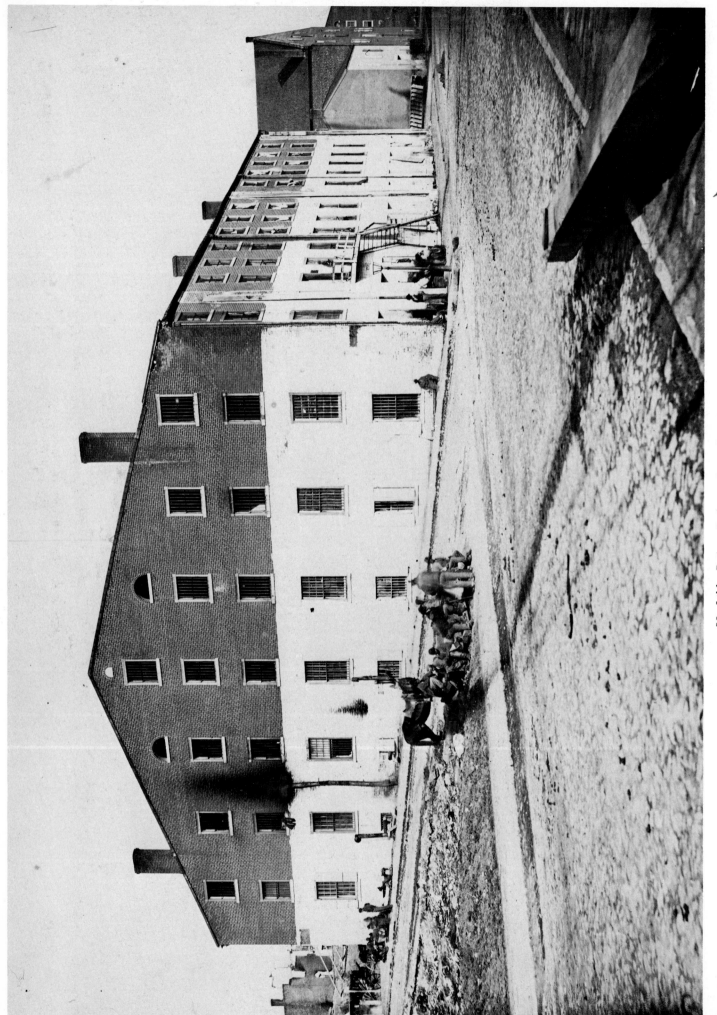

60. Libby Prison, Richmond; April 1865.

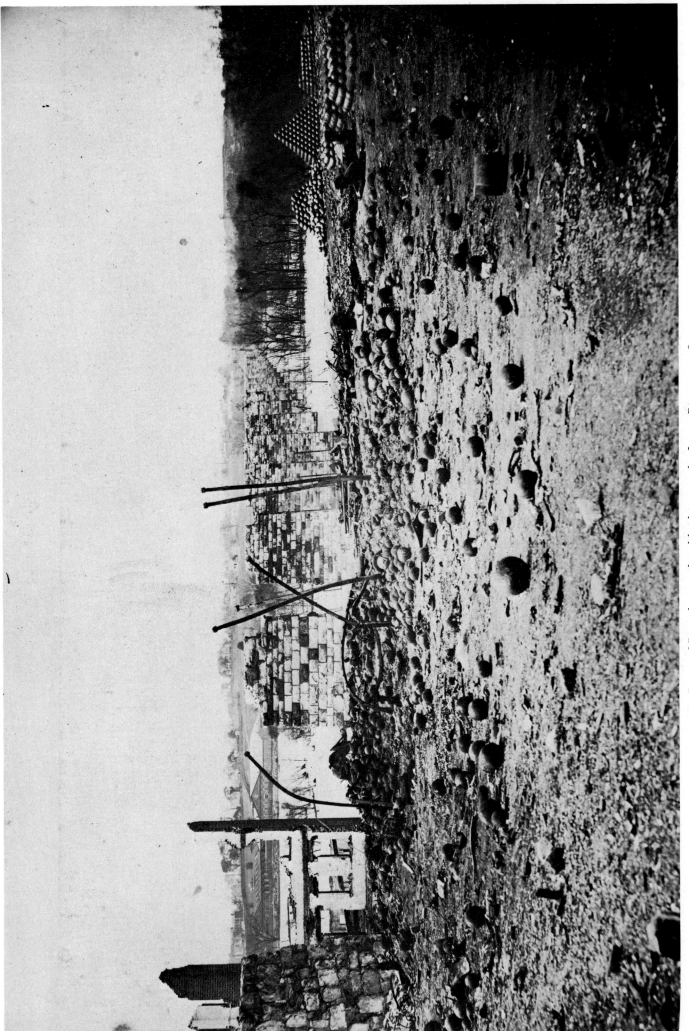

61. Ruins of Petersburg railroad bridge over the James River, seen from the Richmond side; April 1865.

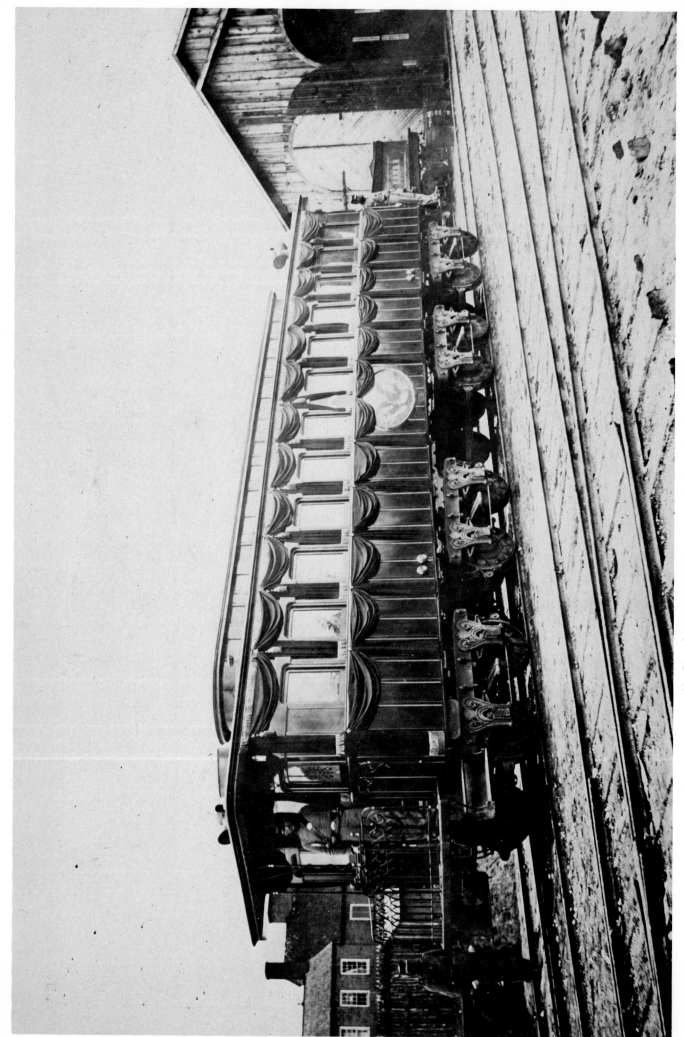

62. President Lincoln's funeral car at Alexandria; April 1865.

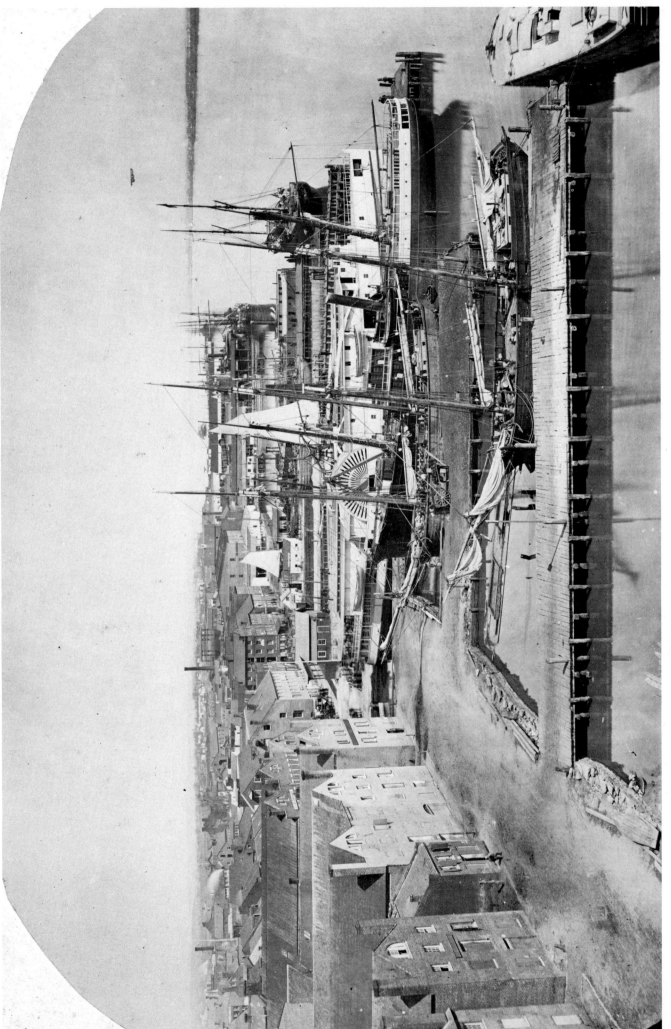

63. View up the wharf from Pioneer Mill, Alexandria; May 1865.

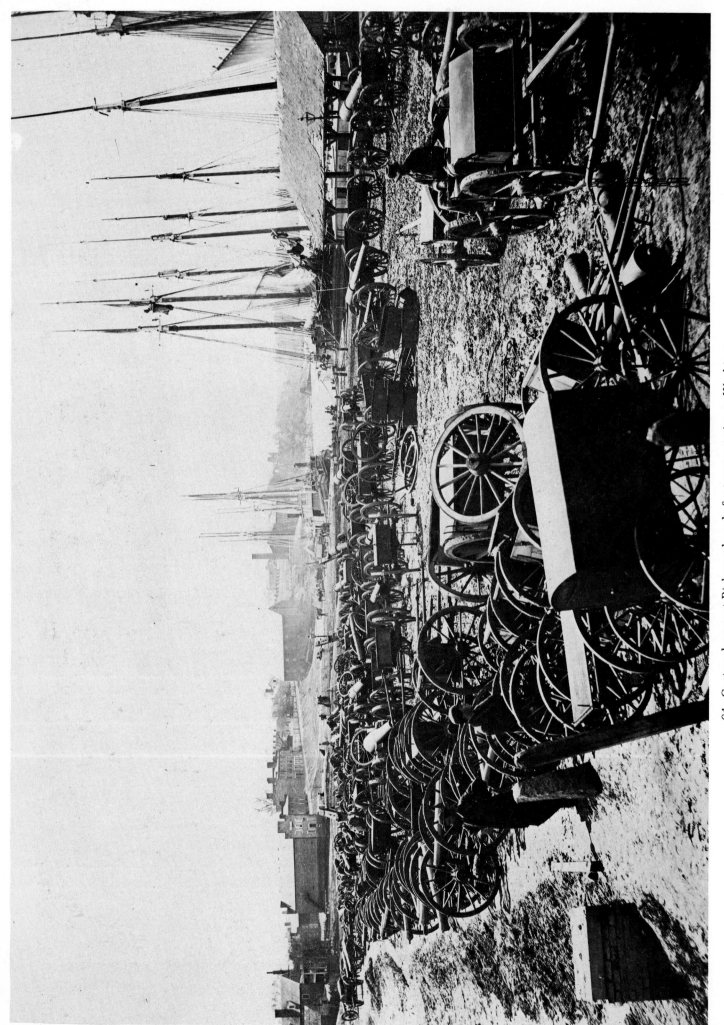

64. Captured guns at Richmond ready for transportation to Washington;
May 1865.

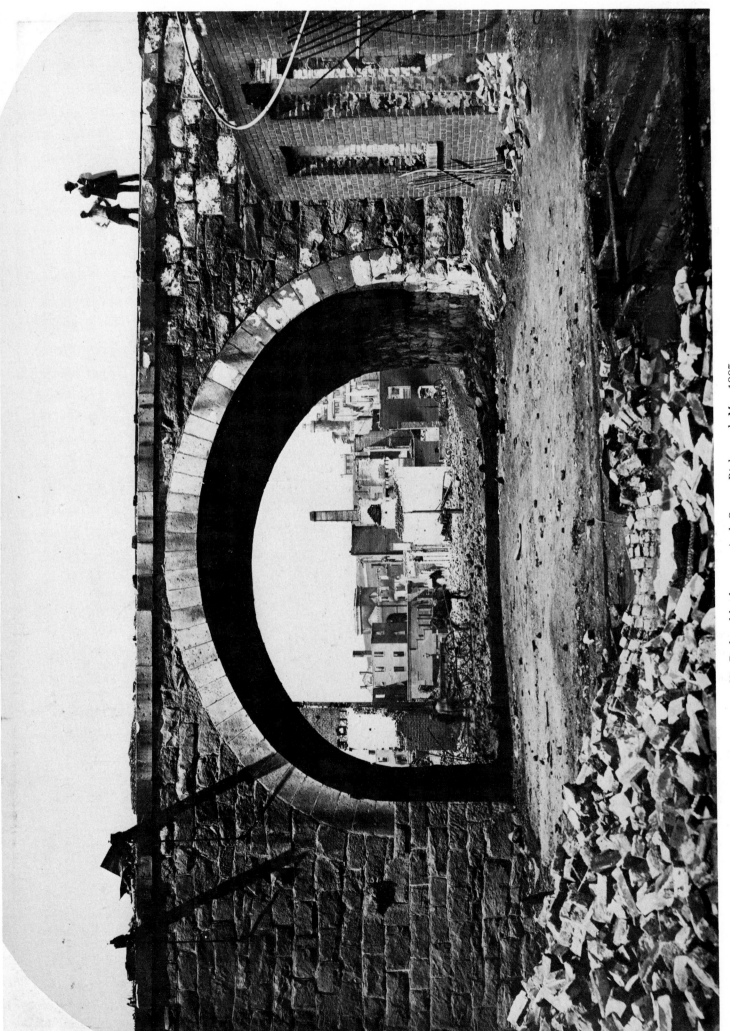

65. Railroad bridge over Arch Street, Richmond; May 1865.

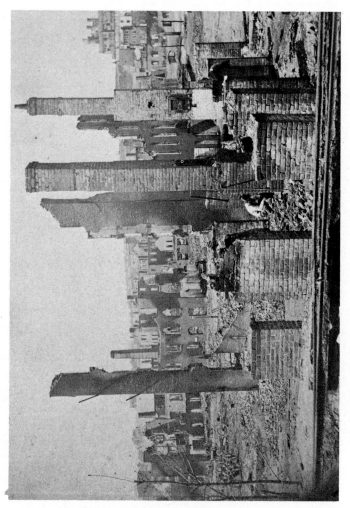

66. Ruins in Richmond, corner of Carey and Governor Streets; May 1865.

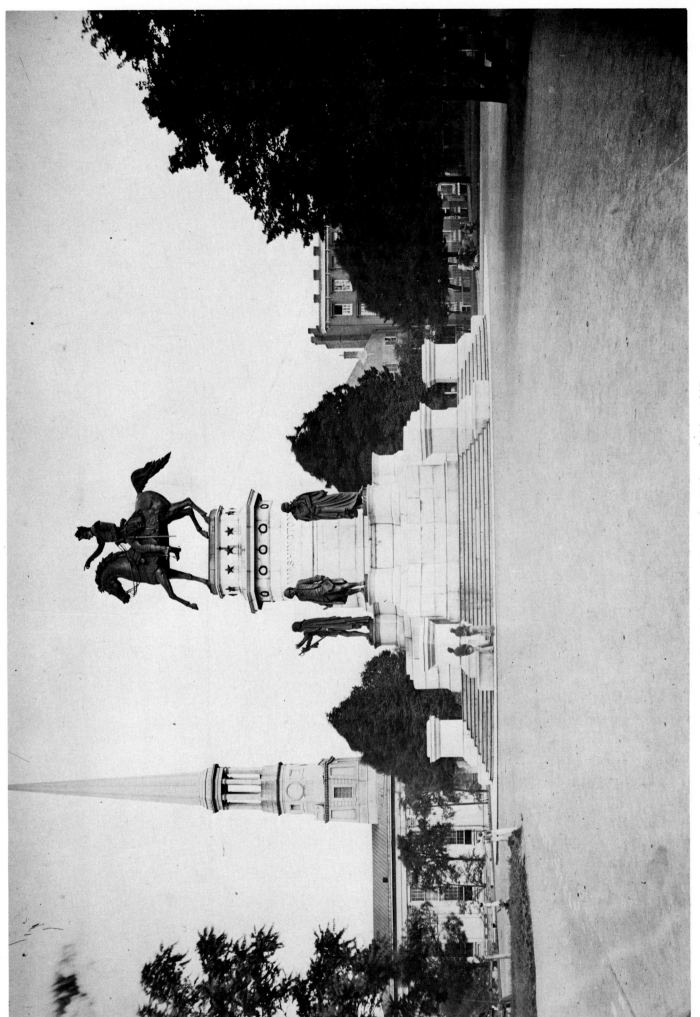

67. Washington Monument, Richmond; May 1865.

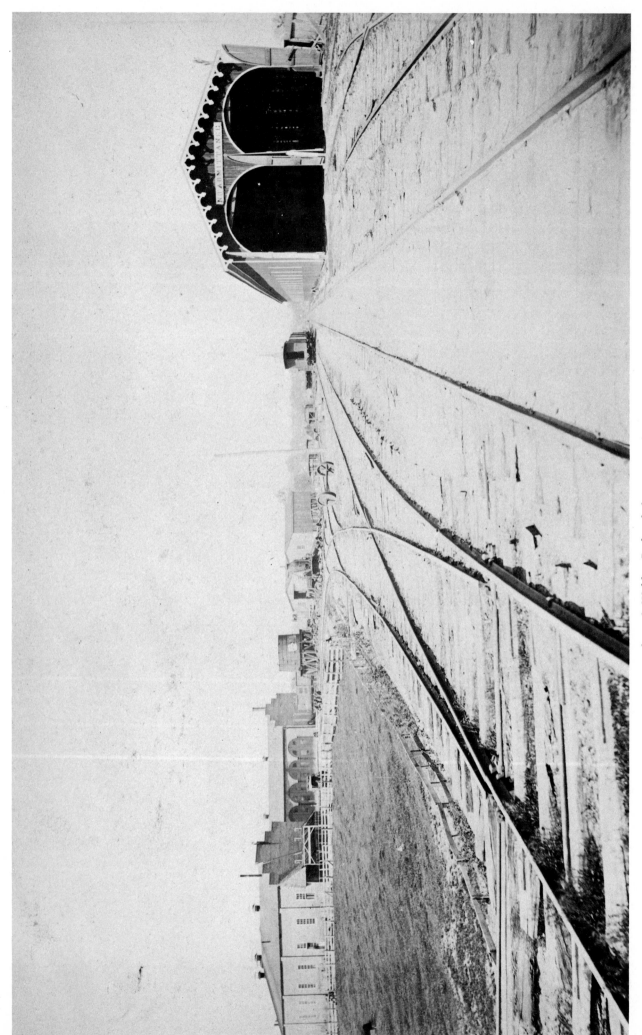

68. Petersburg & Weldon Railroad shops, Petersburg; May 1865.

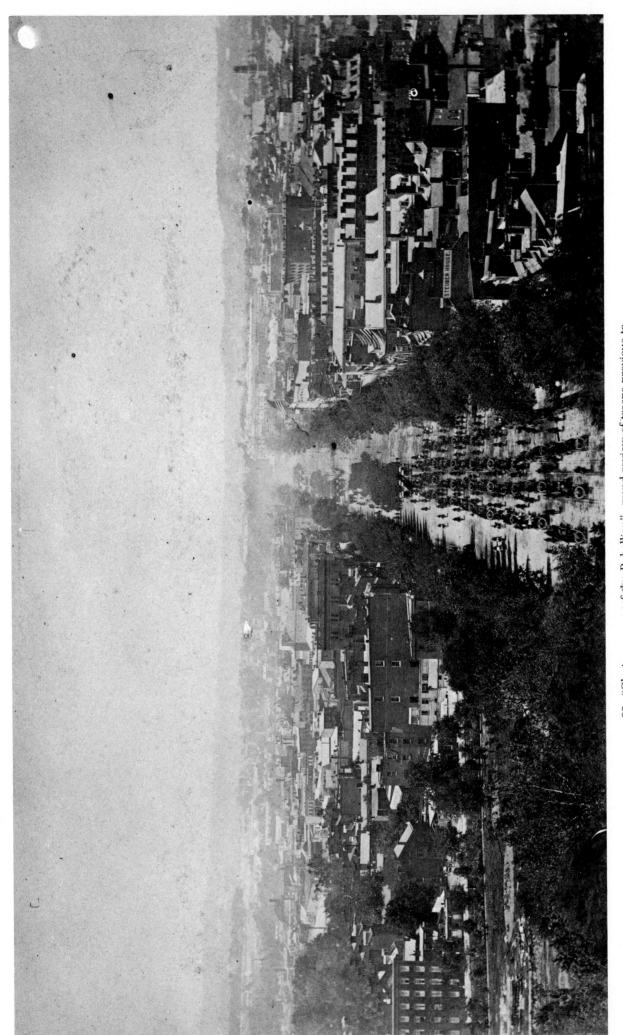

69. "Closing scenes of the Rebellion": grand review of troops previous to discharge and muster out of service, Pennsylvania Avenue, Washington, D.C. [The photo is undated, but the troop review occurred on May 23 and 24, 1865.]

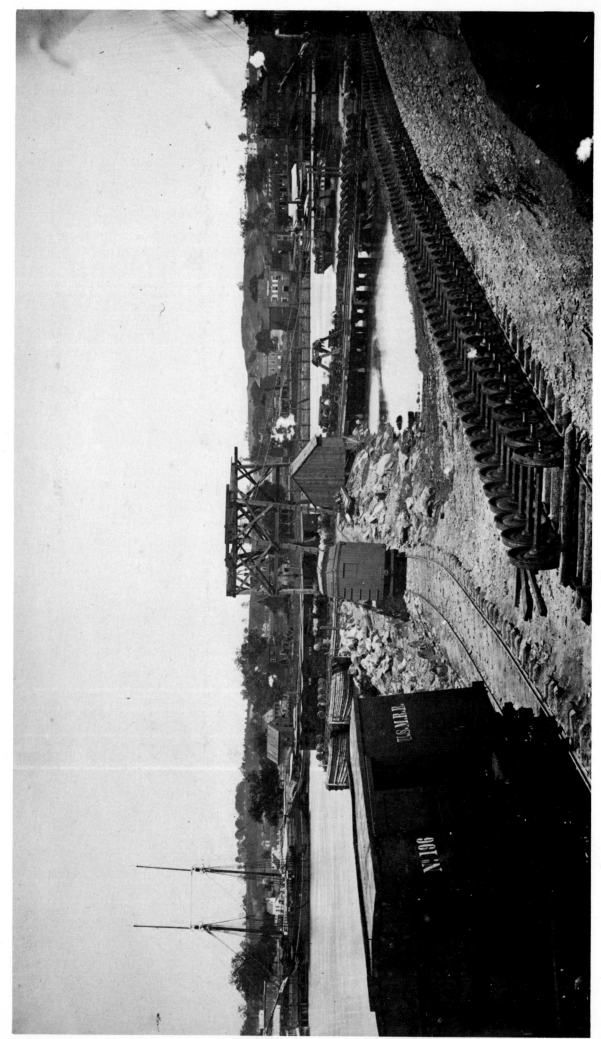

70. Construction Corps unloading cars, Richmond; June 1865.

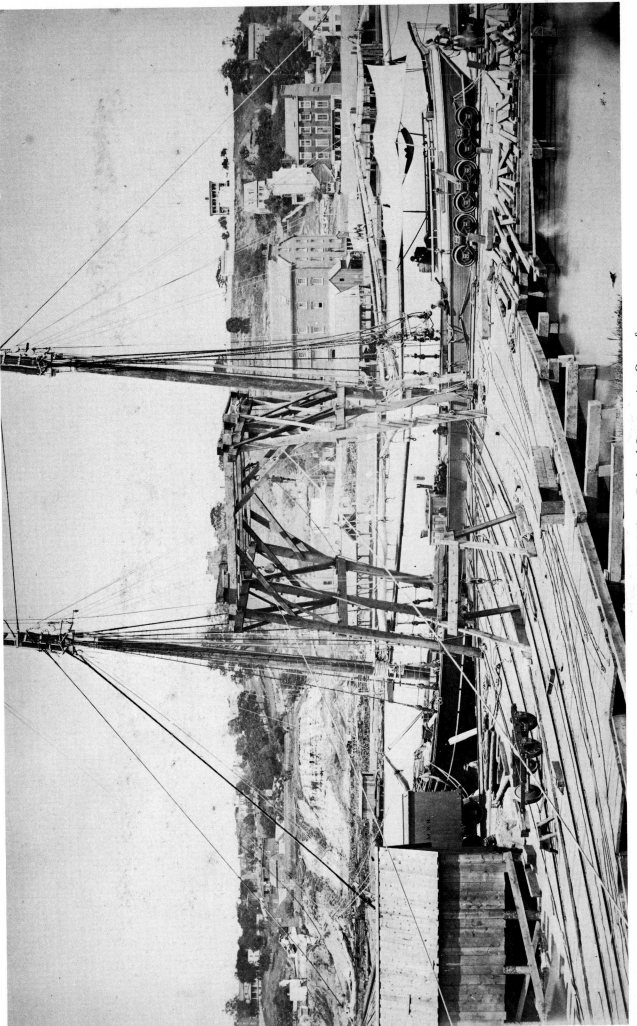

71. Derrick built by the U.S. Military Railroad Construction Corps for unloading cars and engines, Richmond; June 1865.

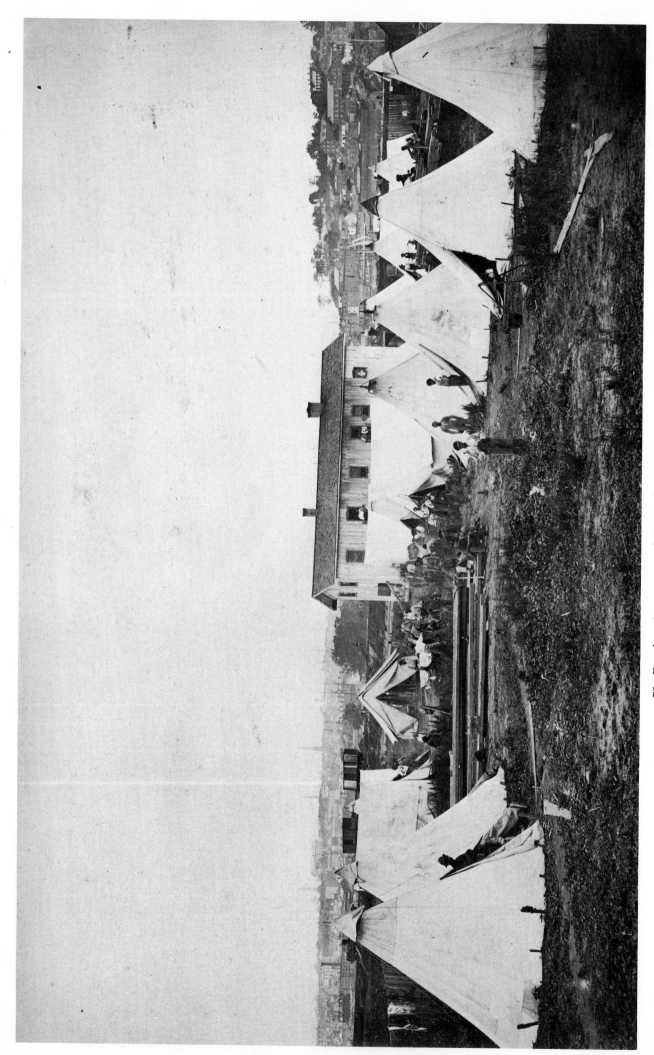

72. Freedmen's camp outside Richmond; June 1865. [This identification, found in Meredith, *Mr. Lincoln's Camera Man*, is preferable to the one in the album: "Camp of Construction Corps Manchester Vª June 1865."]

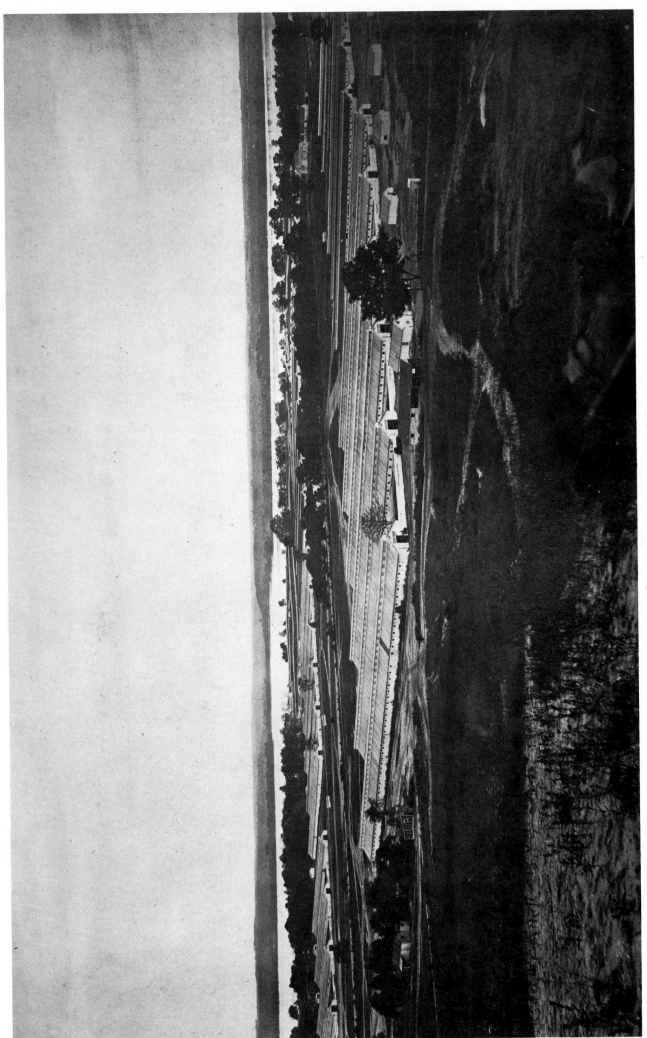

73. General view of the car depot at Giesboro; July 1865.

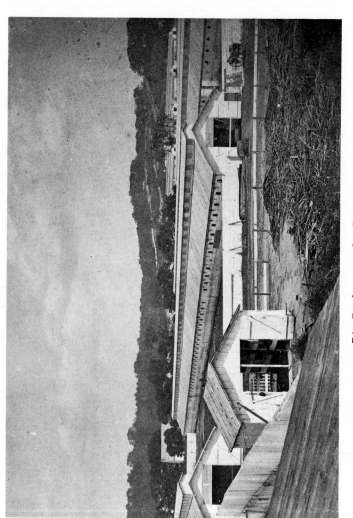

74. Giesboro cavalry depot.

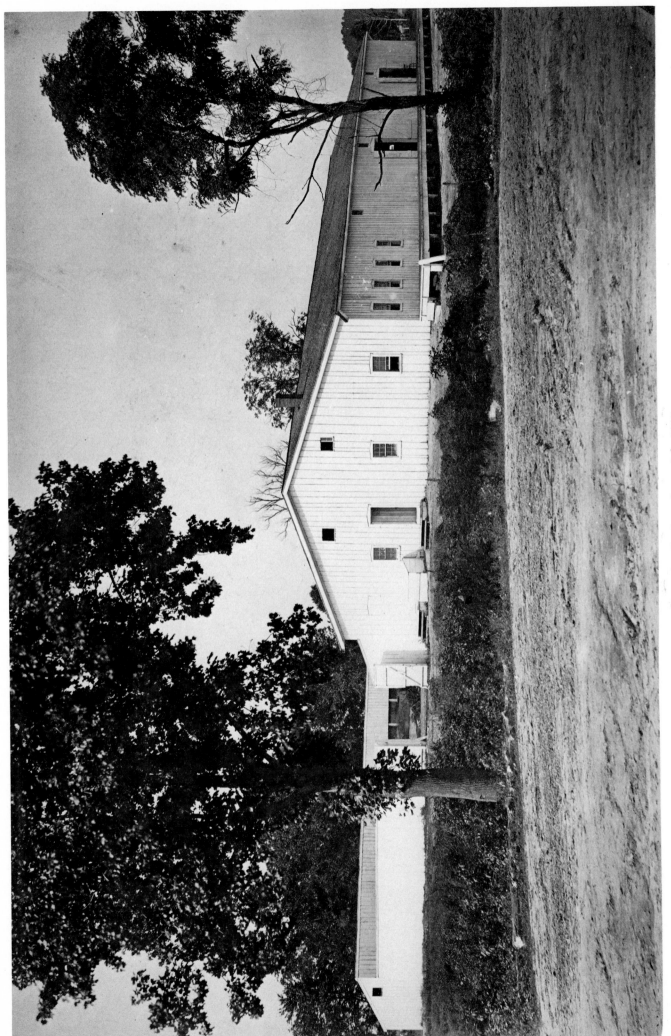

75. Barracks, Giesboro depot; July 1865.

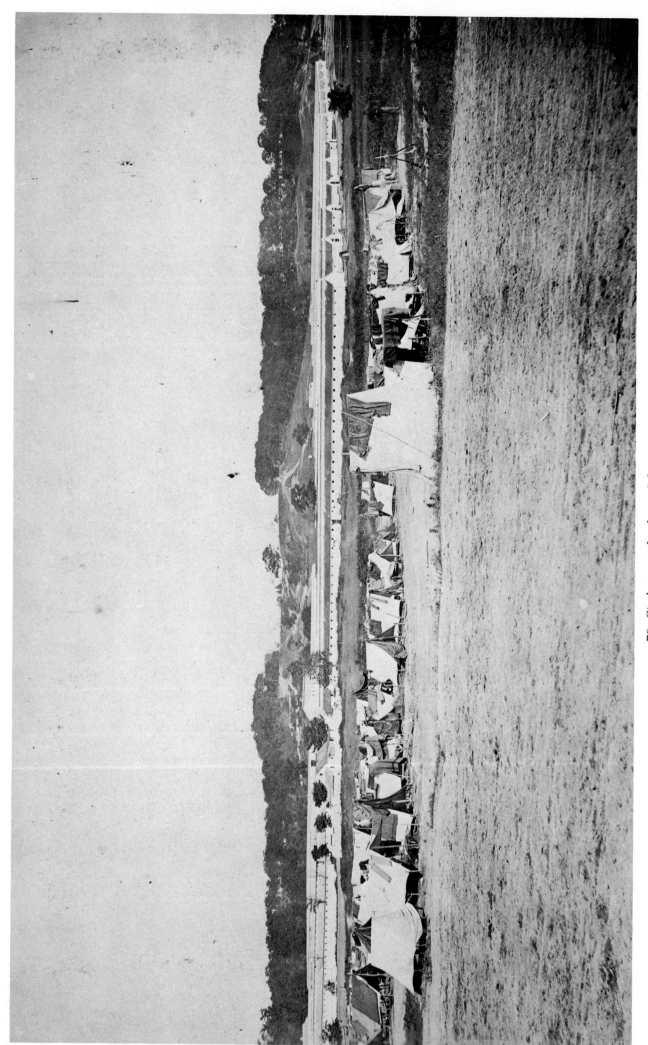

76. Giesboro cavalry depot; July 1865.

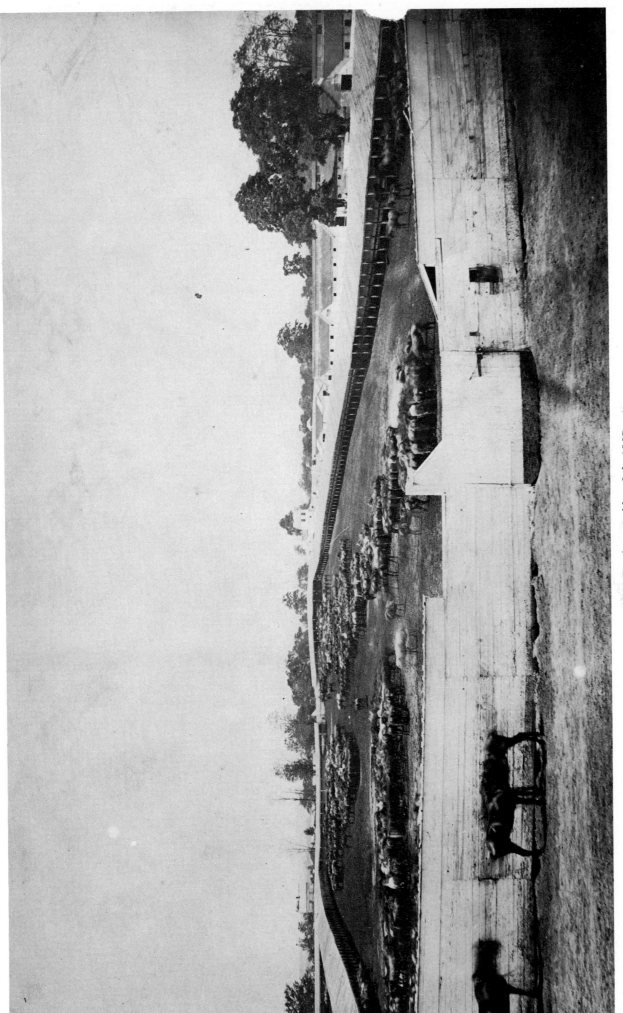

77. Giesboro stables: July 1865.

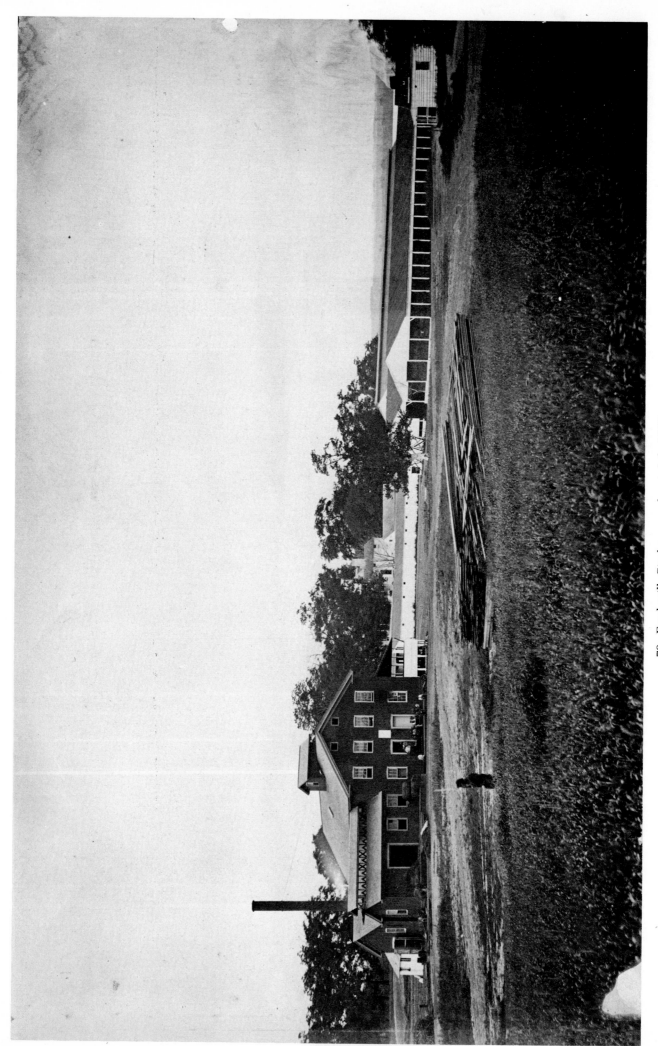

78. Feed mill, Giesboro car depot, July 1865.

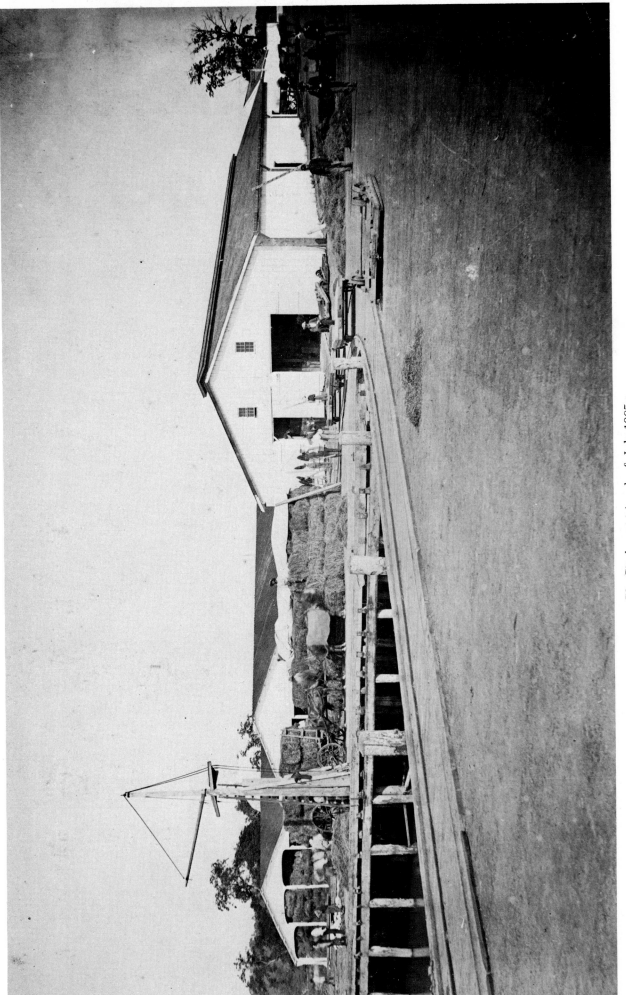

79. Giesboro grain wharf; July 1865.

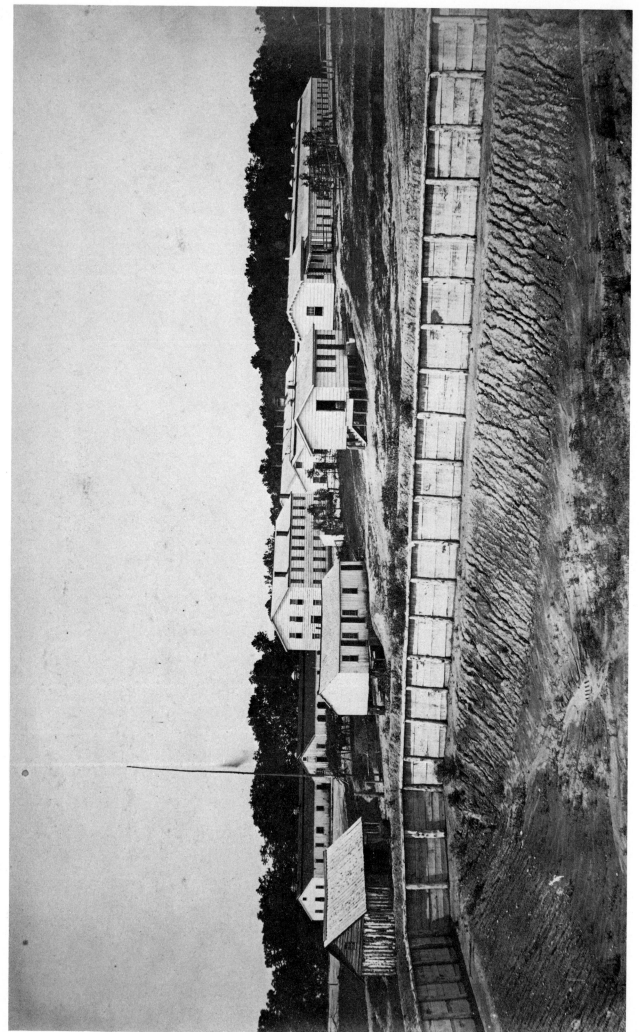

80. Fort Carroll barracks; July 1865.

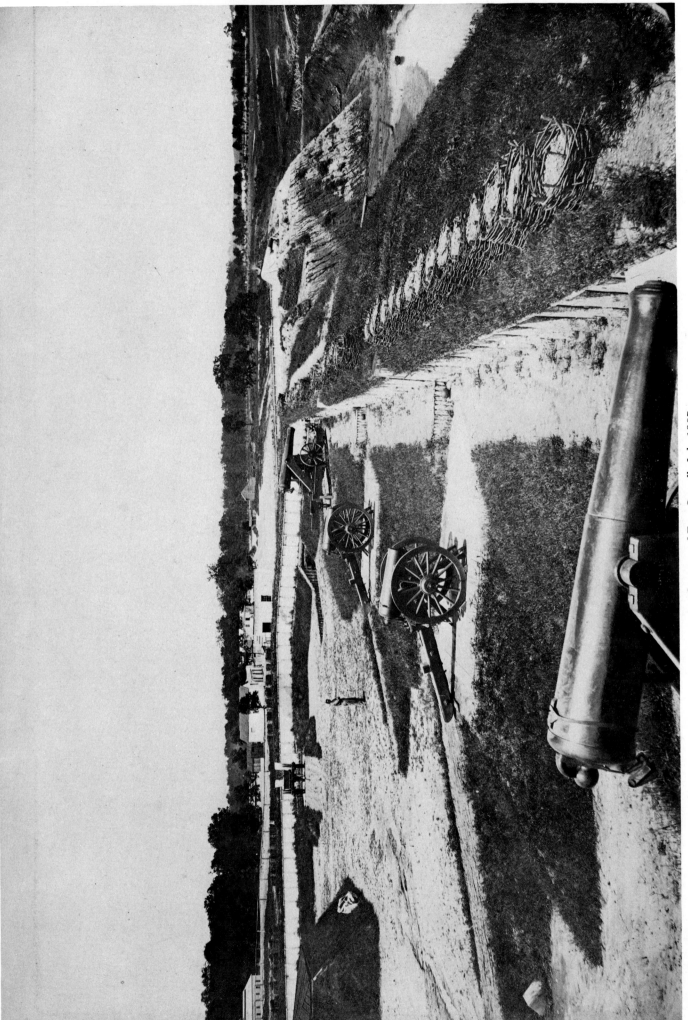

81. Interior of Fort Carroll; July 1865.

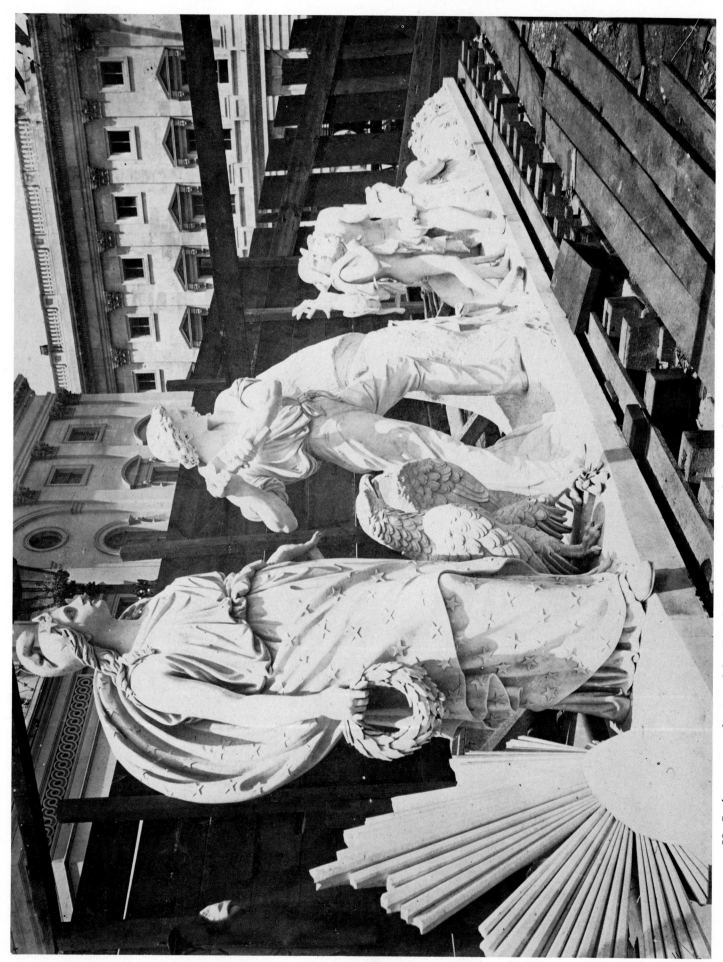

82. Sculpture on north wing of the Capitol (Crawford Pediment), Washington, D.C. (left to right: sunburst, America, eagle, pioneer chopping a tree, hunter, Indian brave, Indian mother and child), photographed while in position in front of the Capitol. [This may be the

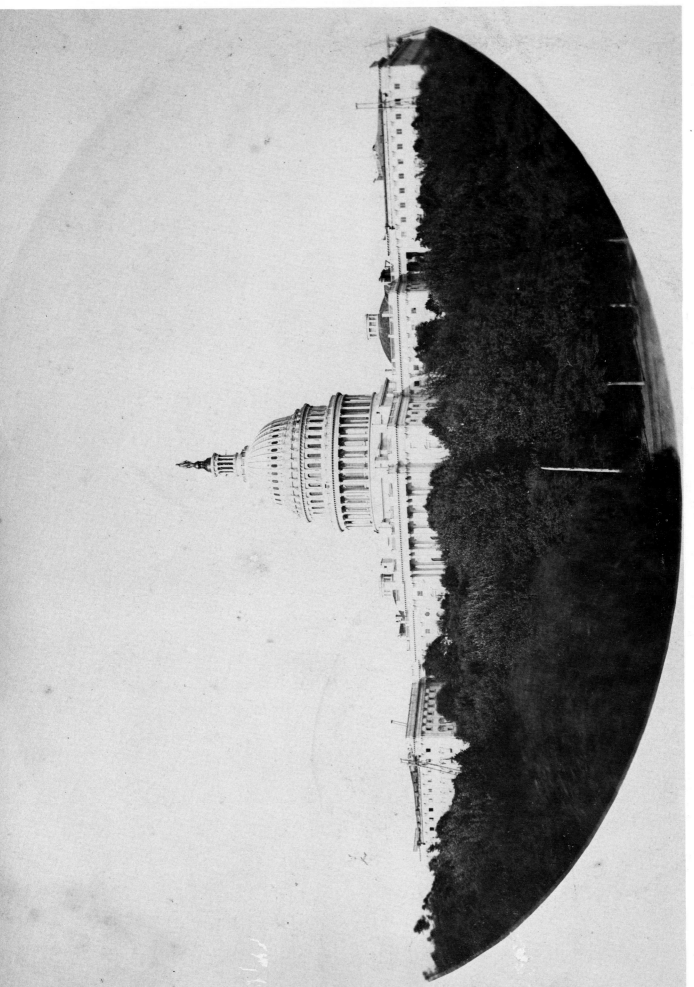

83. The Capitol, with full dome (completed 1865) and construction continuing on the wings.

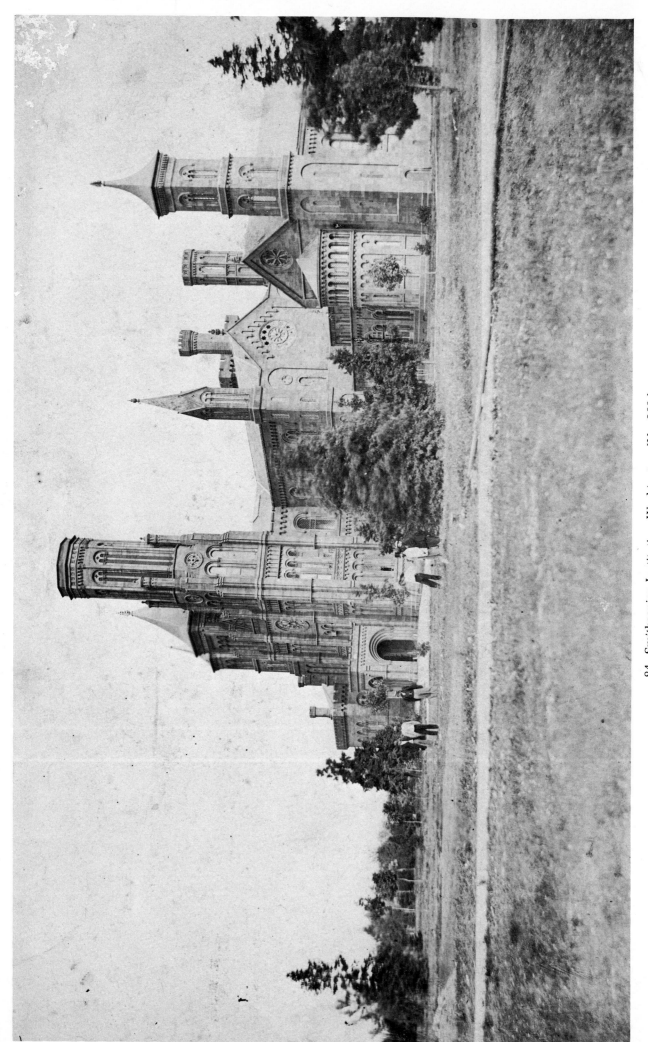

84. Smithsonian Institution, Washington. [No. 269.]

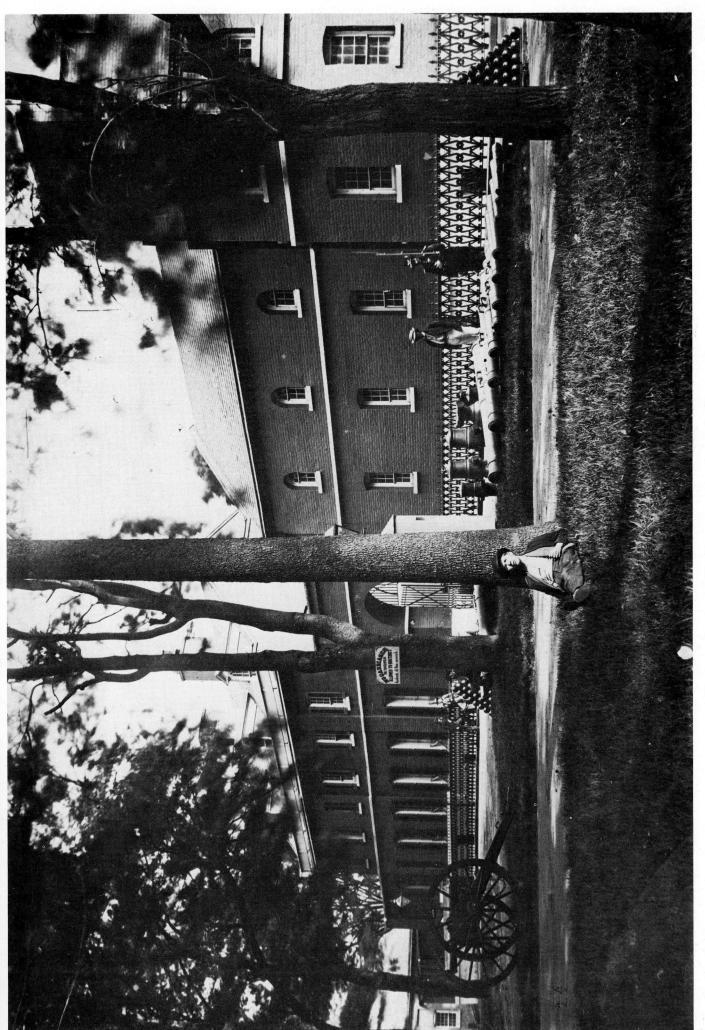

85. Arsenal grounds, Washington; captured guns in foreground.
[No. 203.]

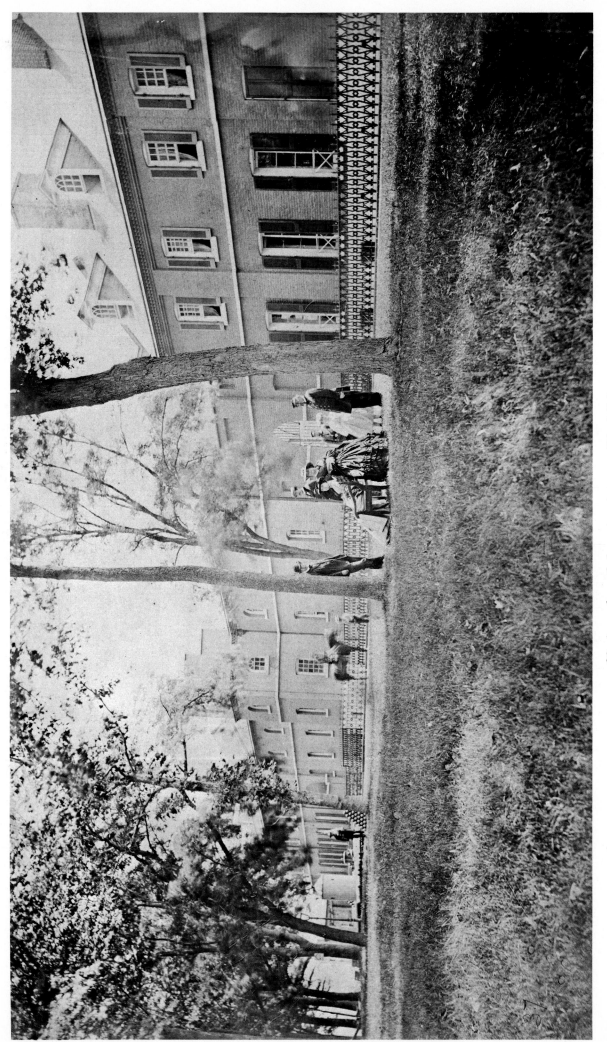

86. Arsenal, north front, interior court. [No. 242.]

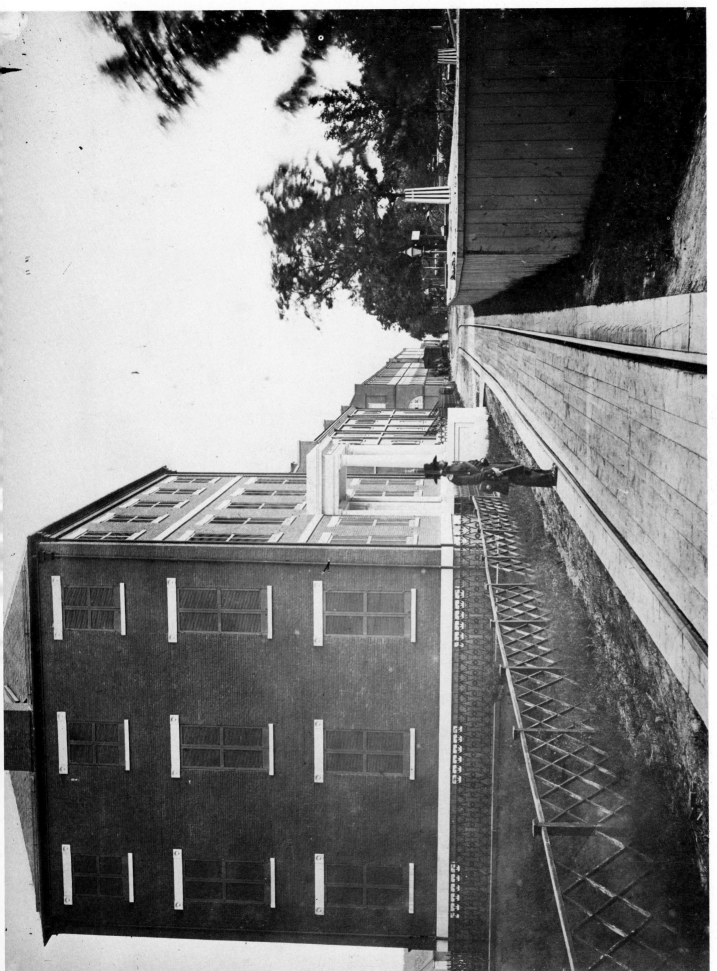

87. Model arsenal, Arsenal Yard. [No. 301.]

88. View in Arsenal Yard. [No. 146.]

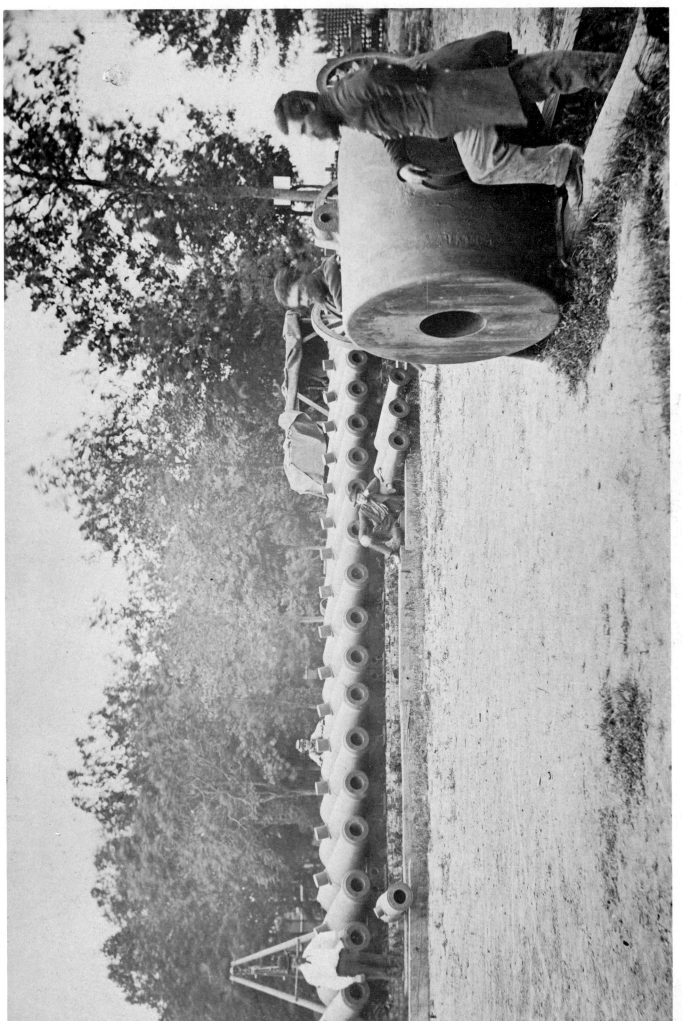

89. Thirteen-inch mortar, Arsenal Yard. [No. 159.]

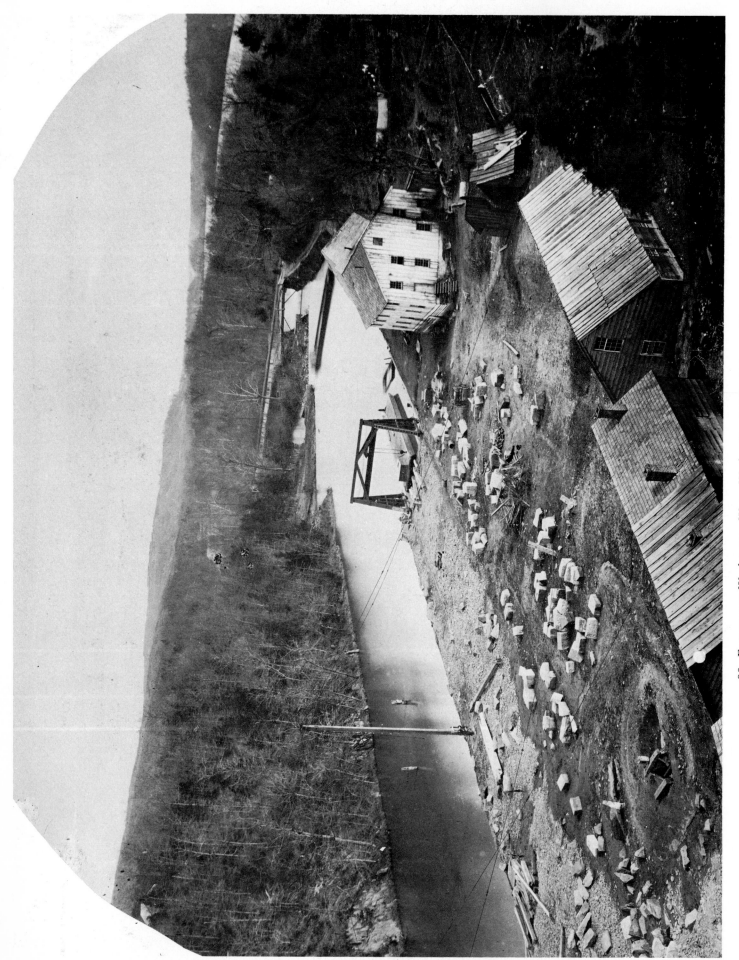

90. Entrance to Washington Water Works, Great Falls, Potomac River.
[No. 191.]

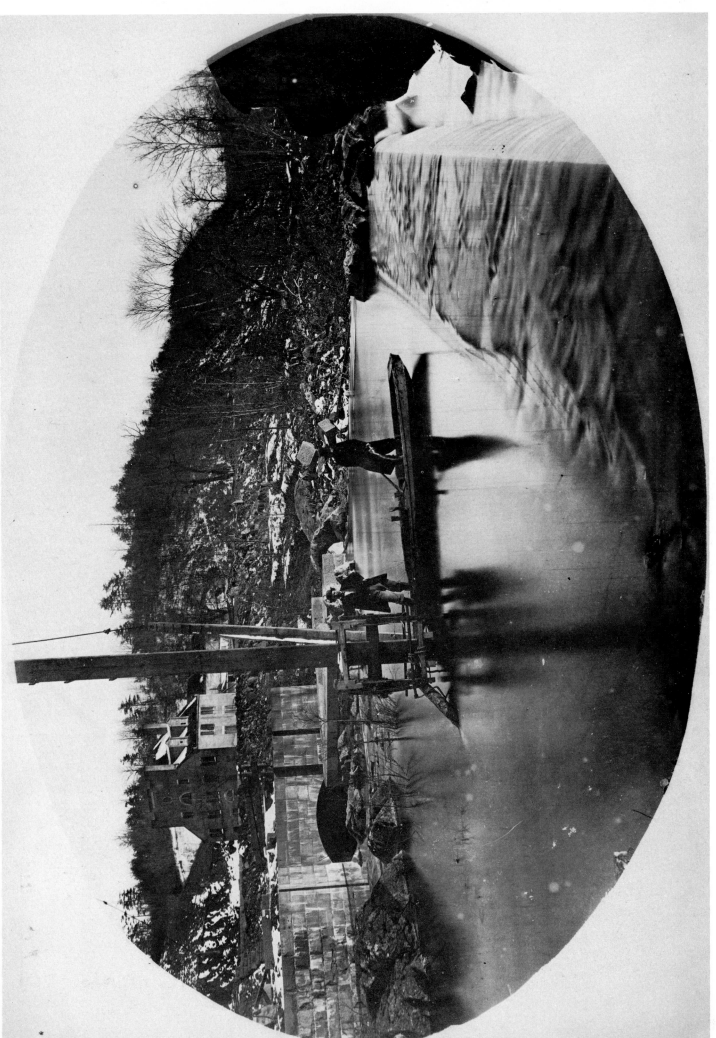

91. Entrance to Washington Water Works. [No. 191 (*sic*).]

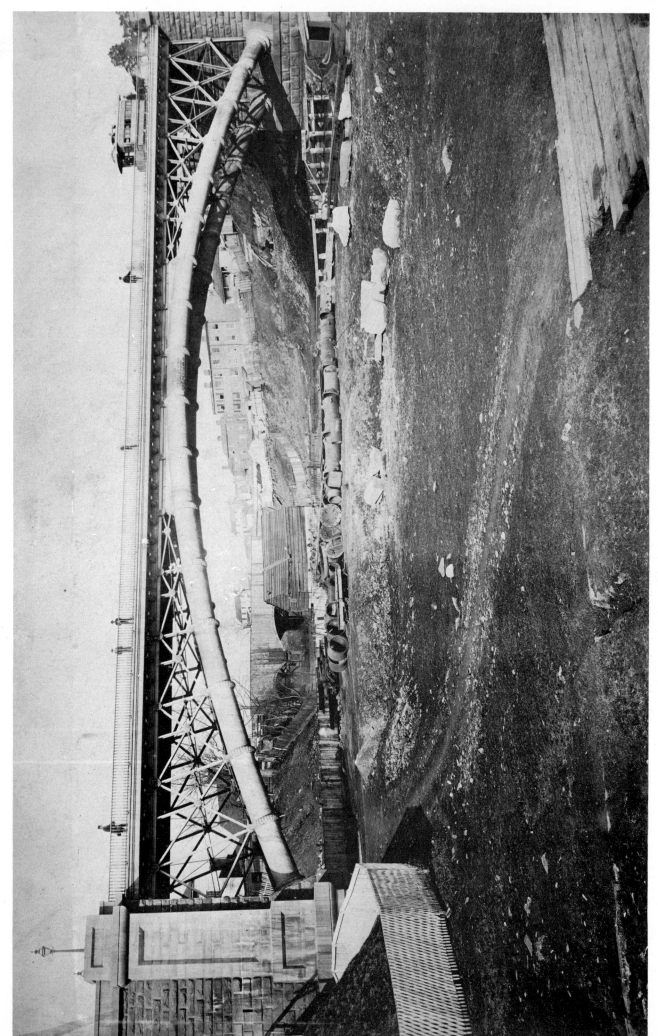

92. Tubular bridge, through the pipes of which the city of Washington is supplied with water; built by General Meigs. [No. 173.]

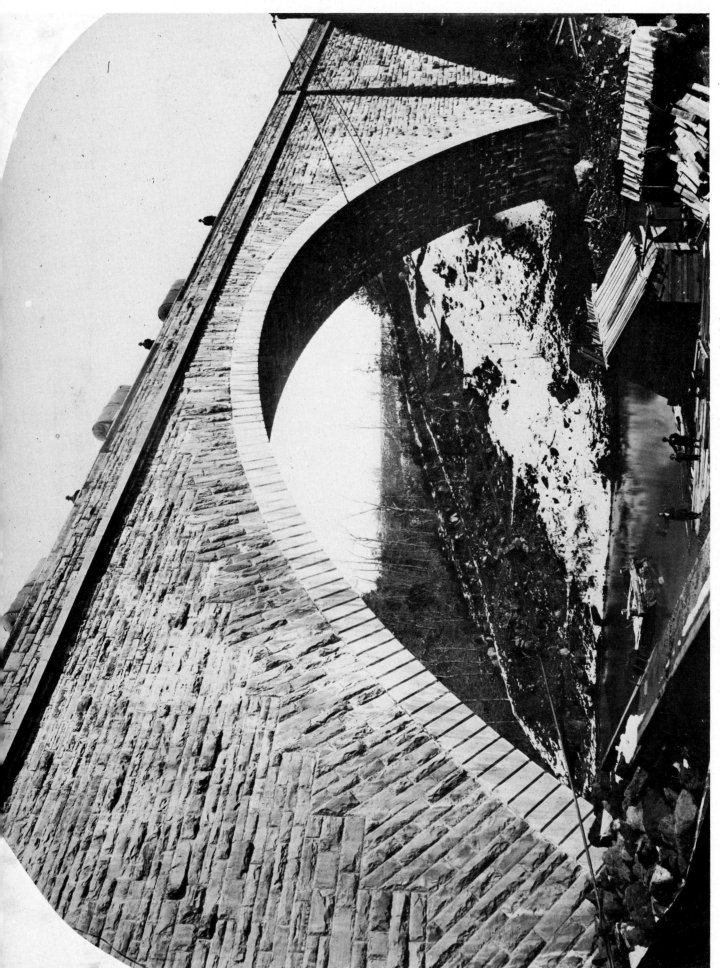

93. Perspective view of Union Arch, Washington Aqueduct; built by General Meigs; span of 220 feet. [No. 302.]

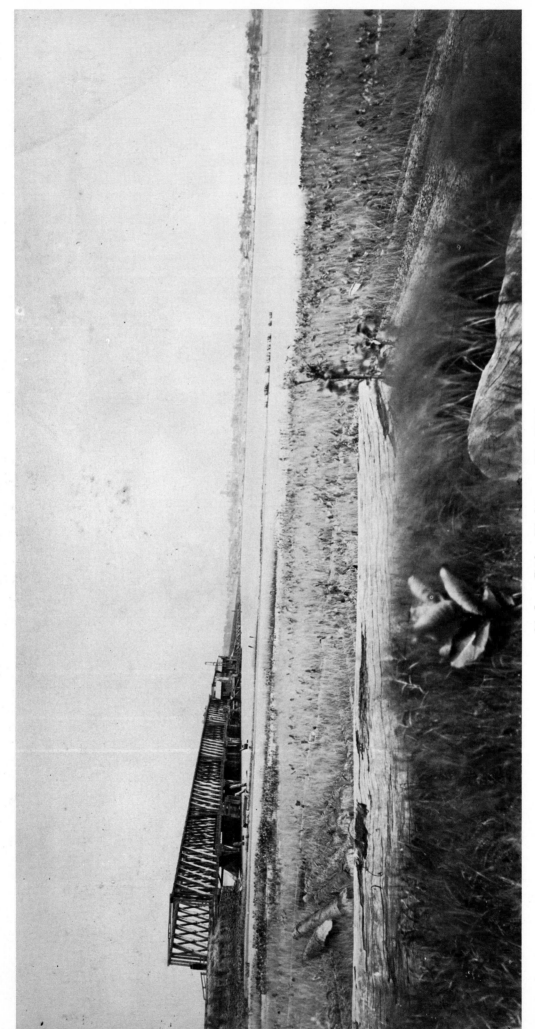

94. Long Bridge, Washington. [No. 275.]

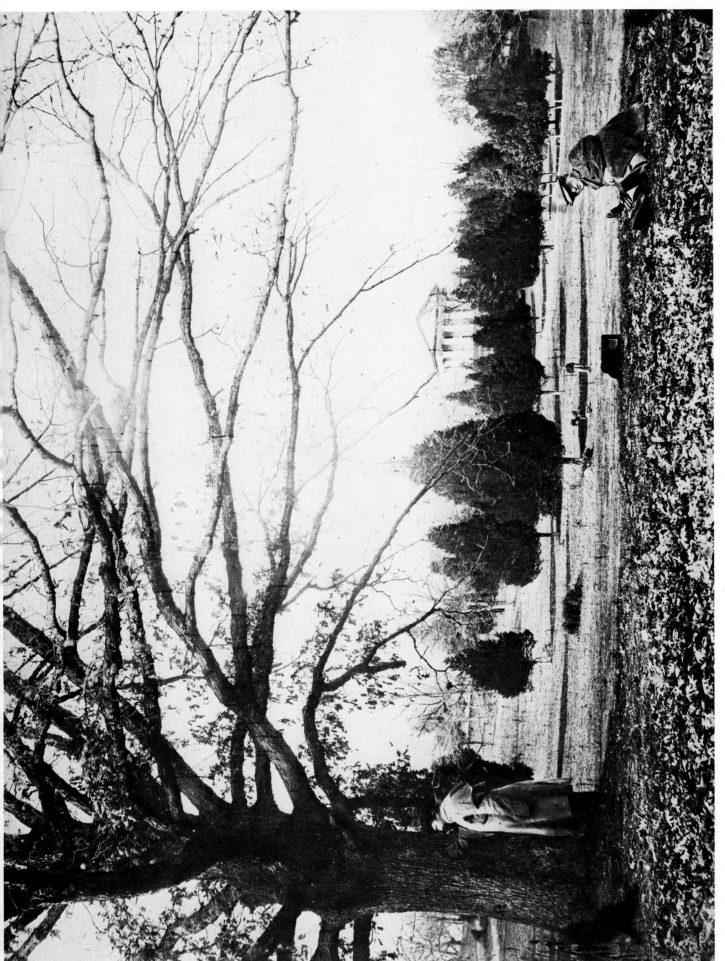

95. Arlington, from the Great Oak. [No. 214.]

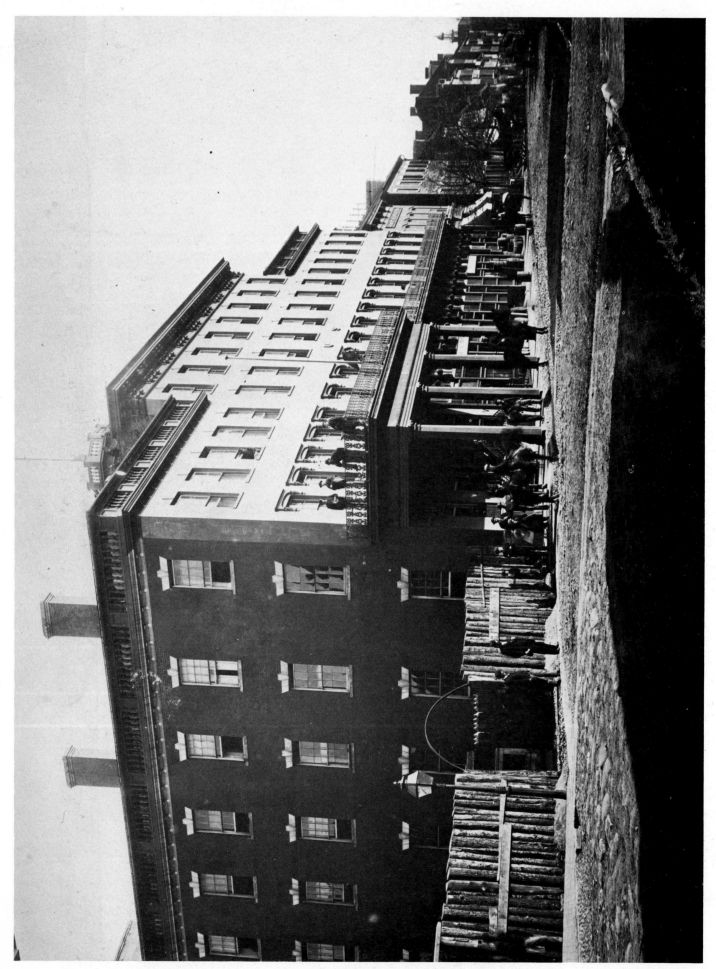

96. Mansion House Hospital, Alexandria. [No. 160.]

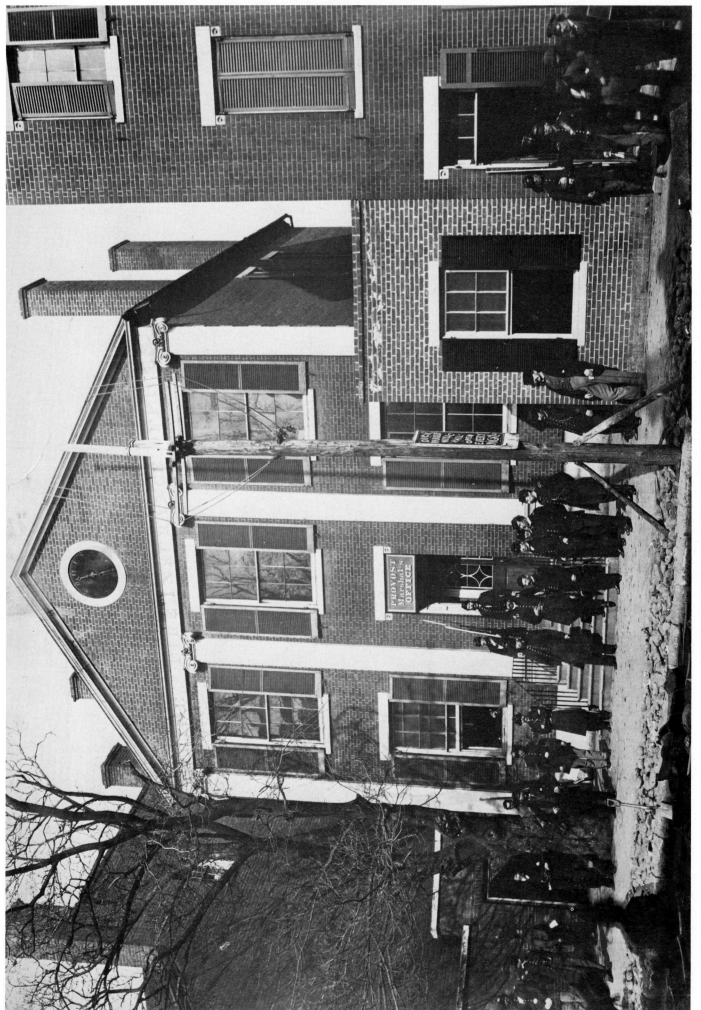

97. Provost Marshal's office, Alexandria. [No. 197.]

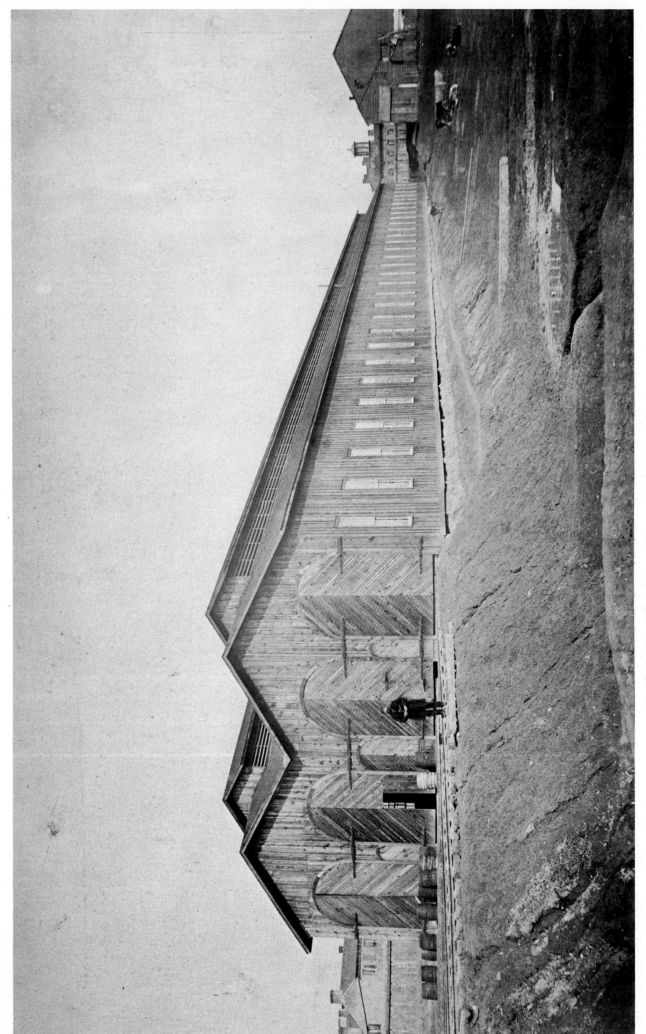

98. Alexandria; "New Engine House, in which Sixty Engines can be stored in working order." [No. 285.]

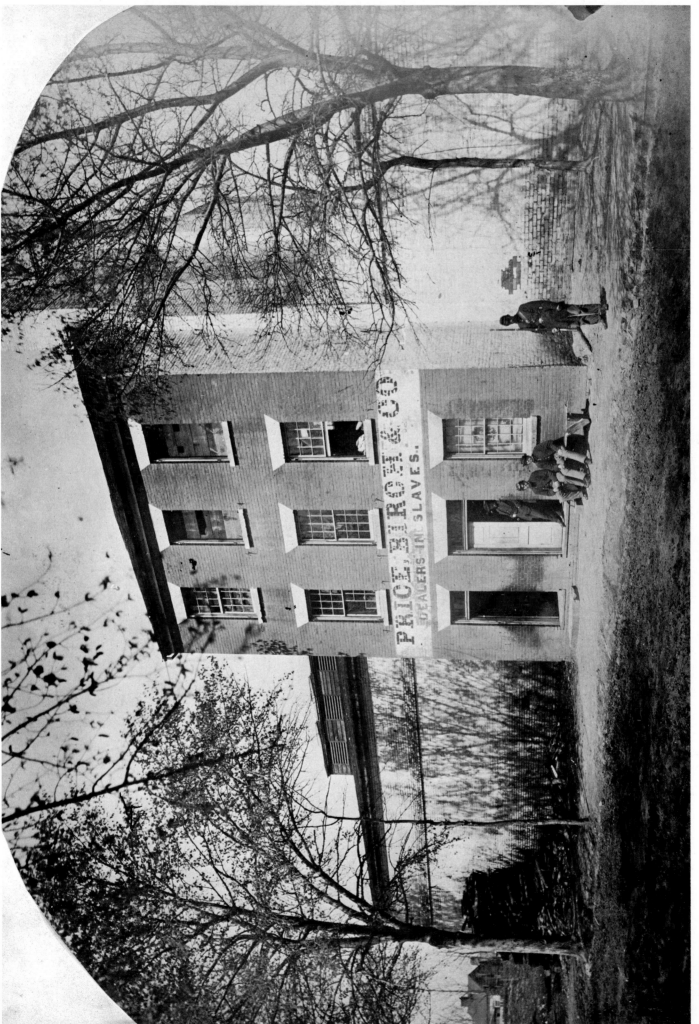

99. Front of a slave pen, Alexandria. [No. 244.]

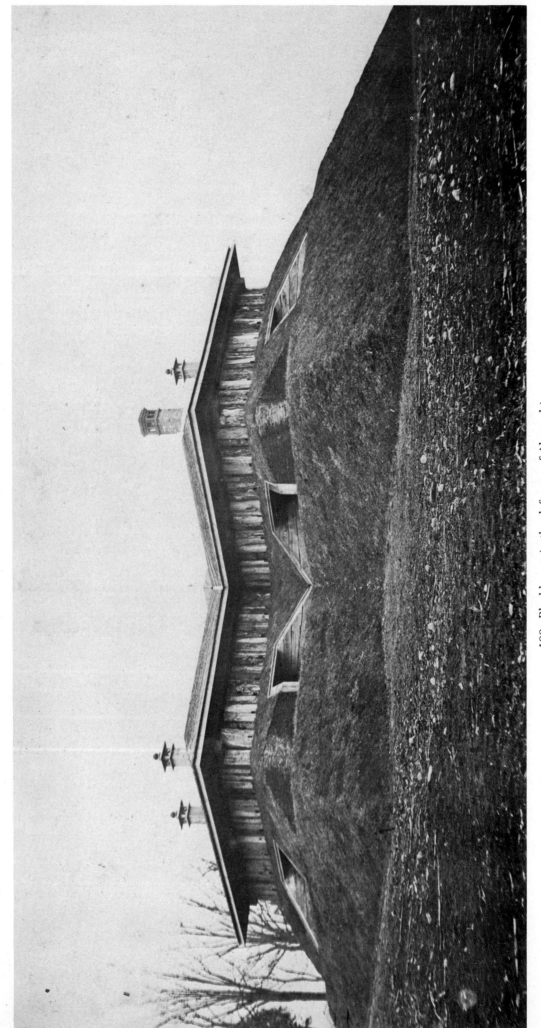

100. Blockhouse in the defenses of Alexandria.

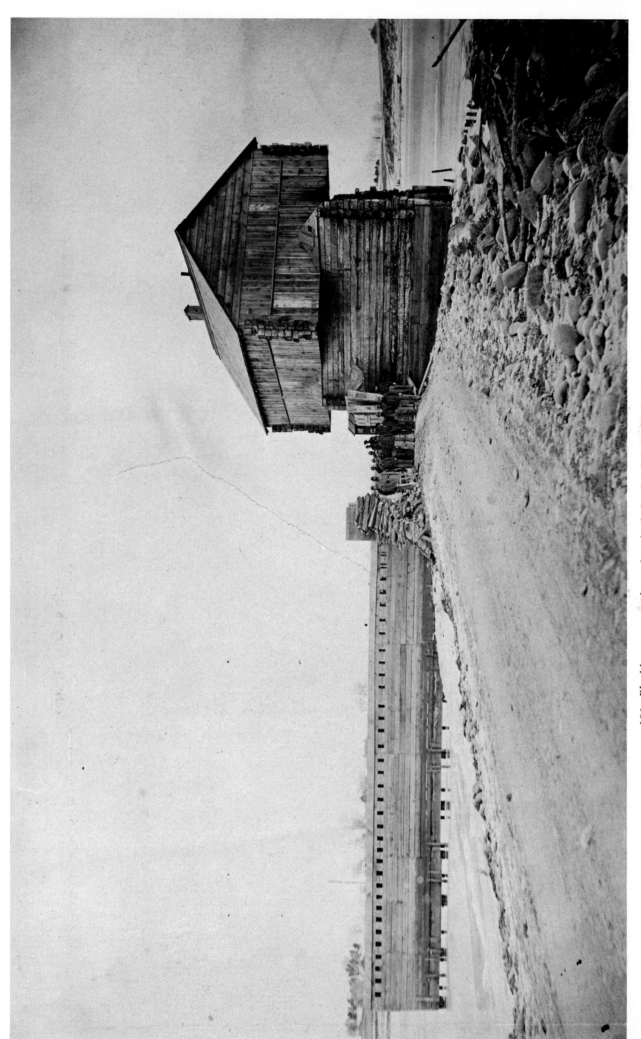

101. Blockhouse near Alexandria, built for the defense of the Orange & Alexandria Railroad.

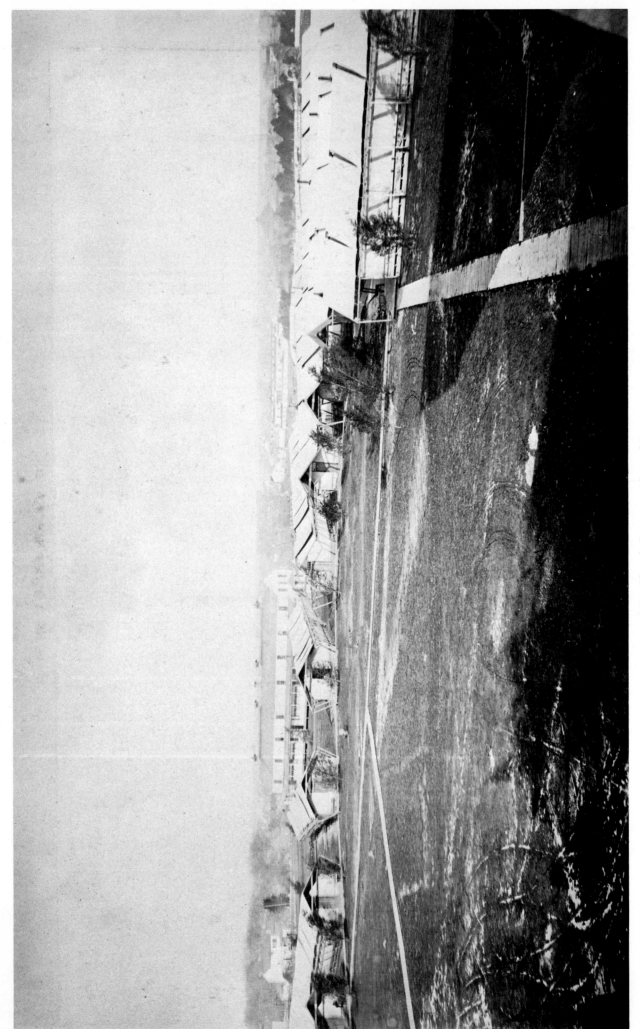

102. Slough Barracas, Alexandria.

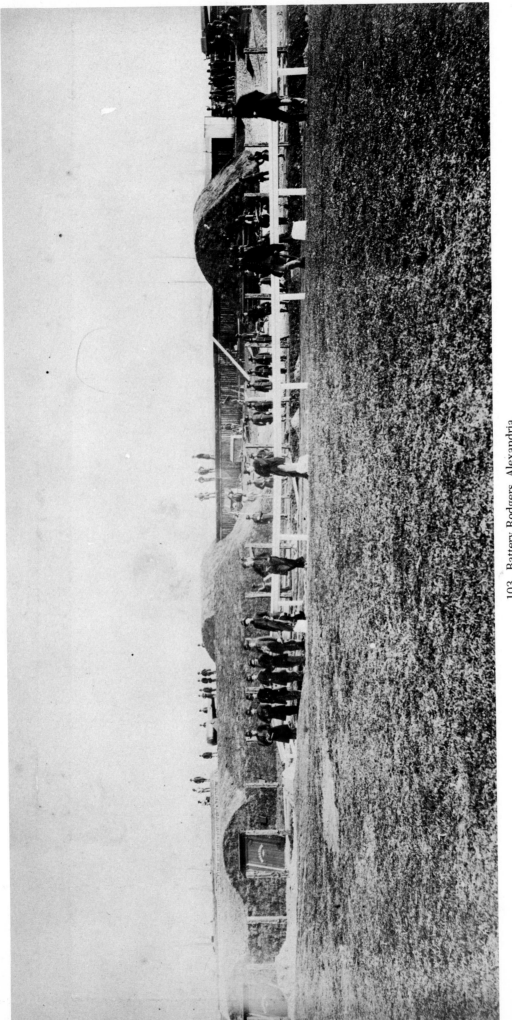

103. Battery Rodgers, Alexandria.

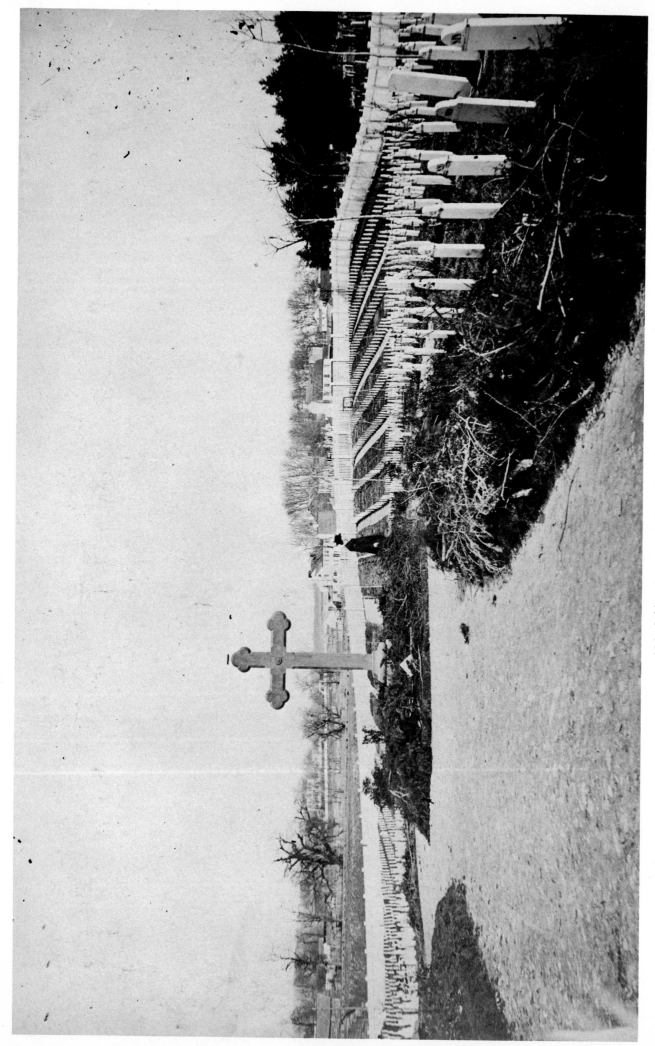

104. Soldiers' cemetery, Alexandria. [No. 187.]

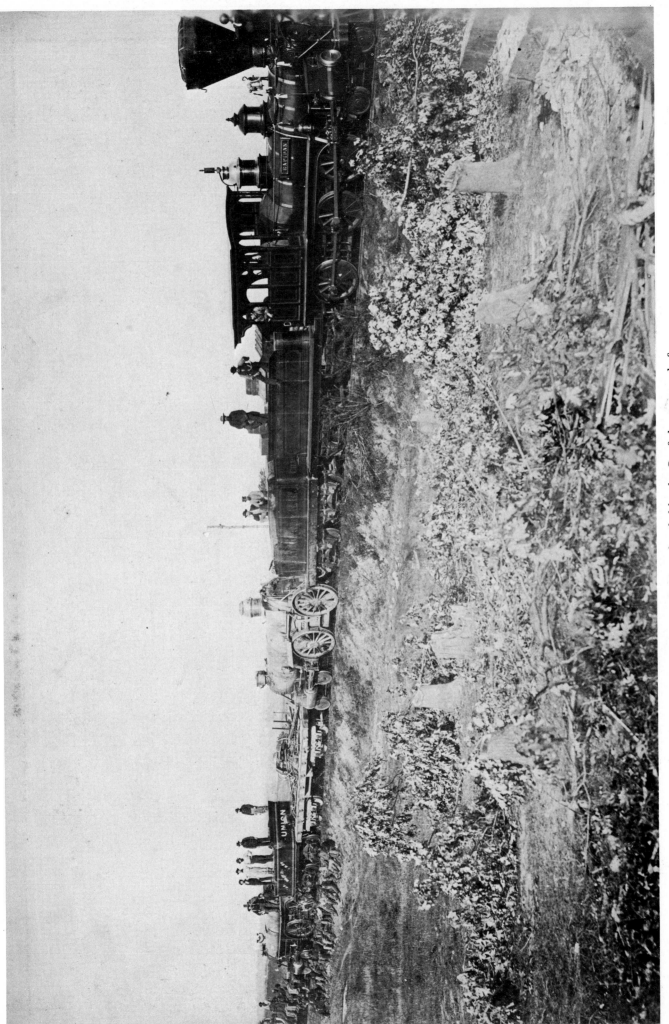

105. Remains of a train derailed by the Confederates, ready for transportation to Alexandria.

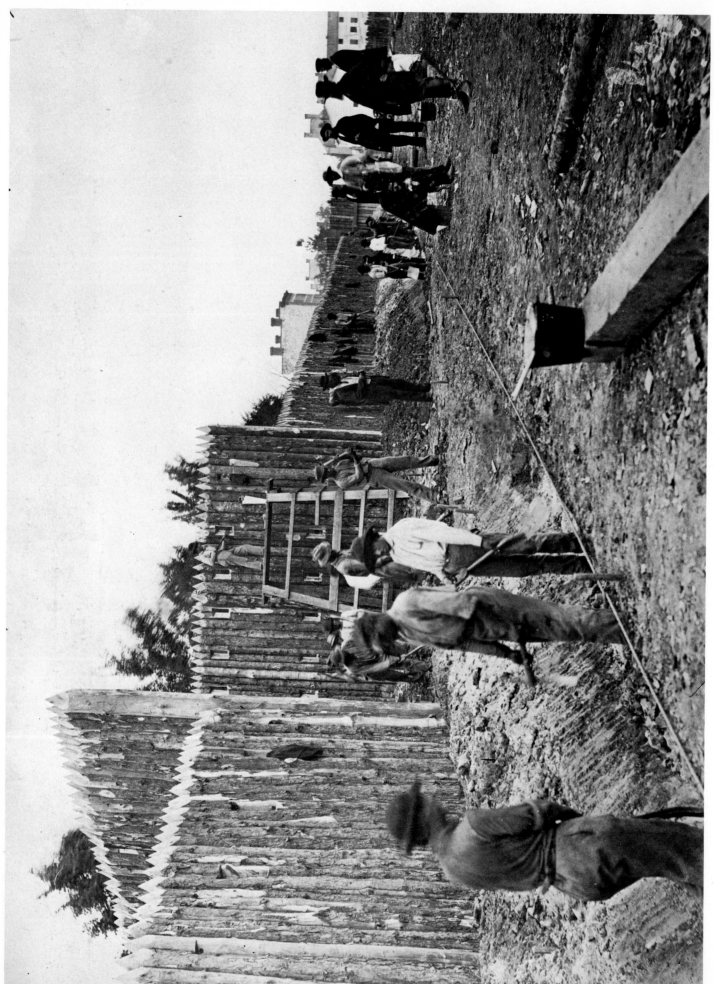

106. Stockade built by order of General Haupt for the protection of government property, enclosing the machine shops and yard of the Orange & Alexandria Railroad. [No. 294.]

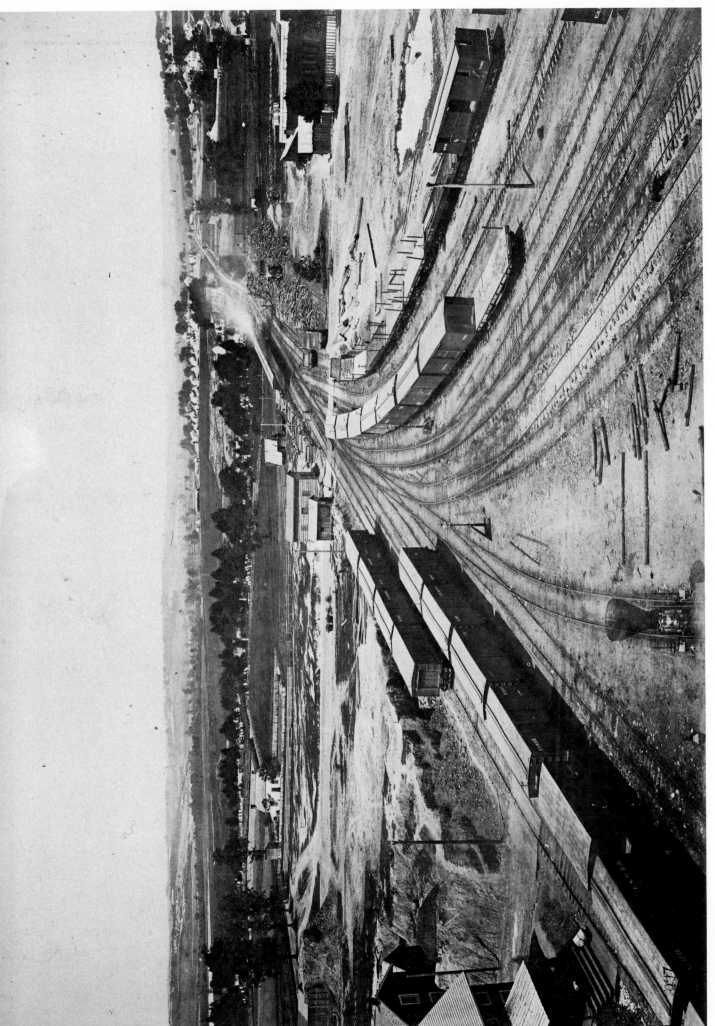

107. View from the roundhouse of the Orange & Alexandria Railroad at Alexandria. [No. 185.]

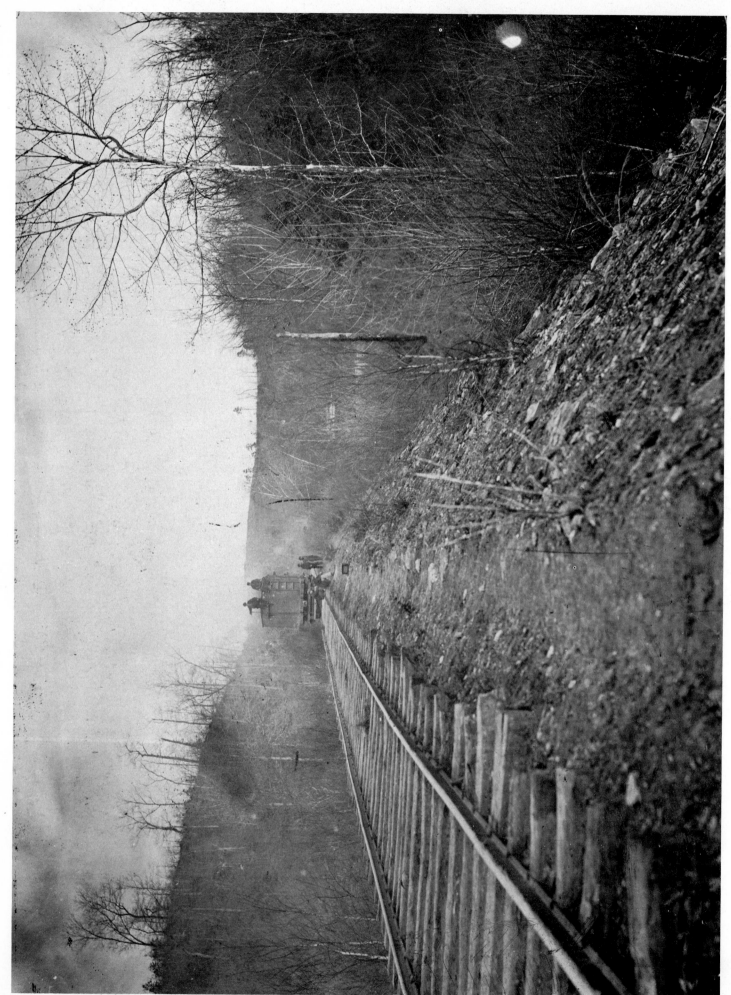

108. Embankment near Union Mills station, Orange & Alexandria Railroad. [No. 127.]

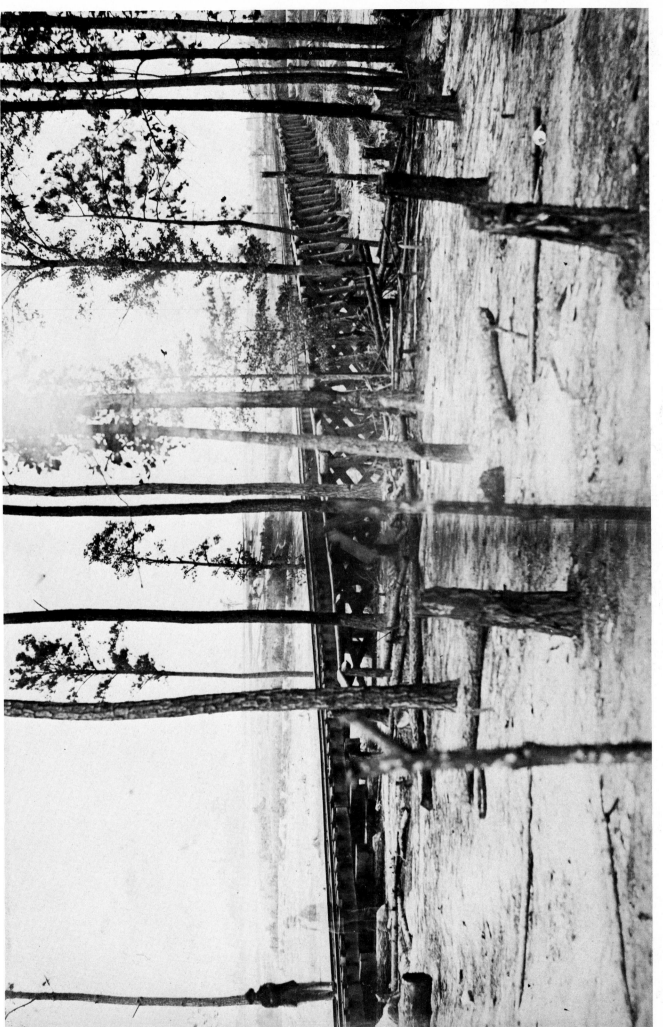

109. Trestle work on City Point & Army Railroad.

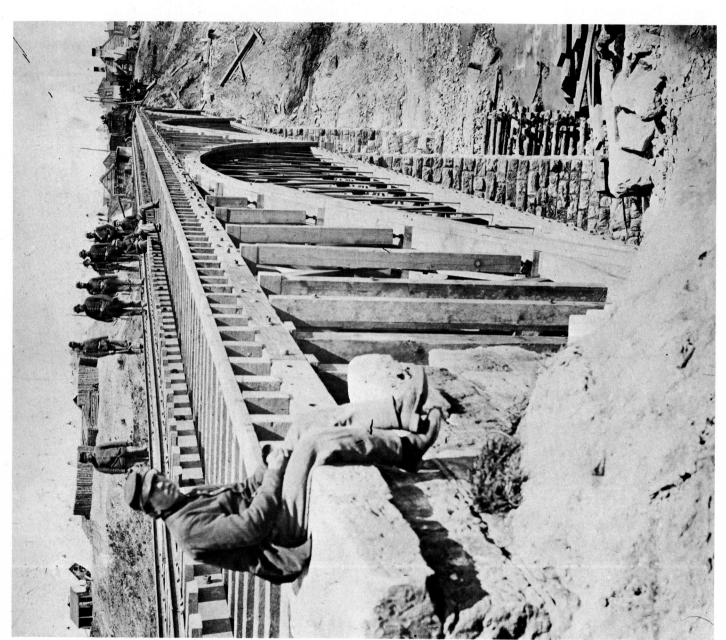

110. Potomac Creek Bridge on the Aquia Creek Railroad, built by order of General Haupt.

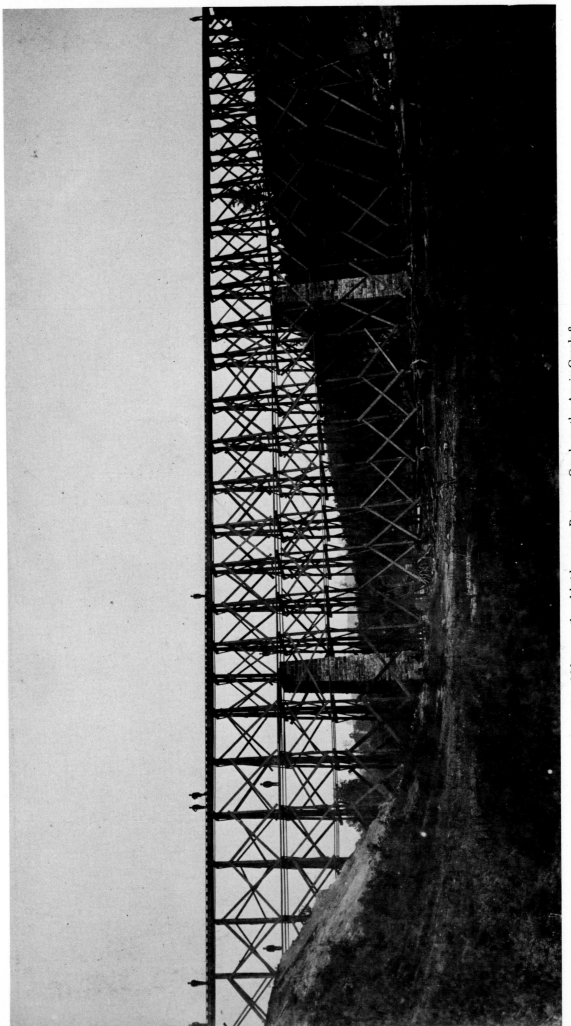

111. Military railroad bridge over Potomac Creek on the Aquia Creek & Fredericksburg Railroad, built by the U.S. Military Railroad Construction Corps in 40 hours. [No. 268.]

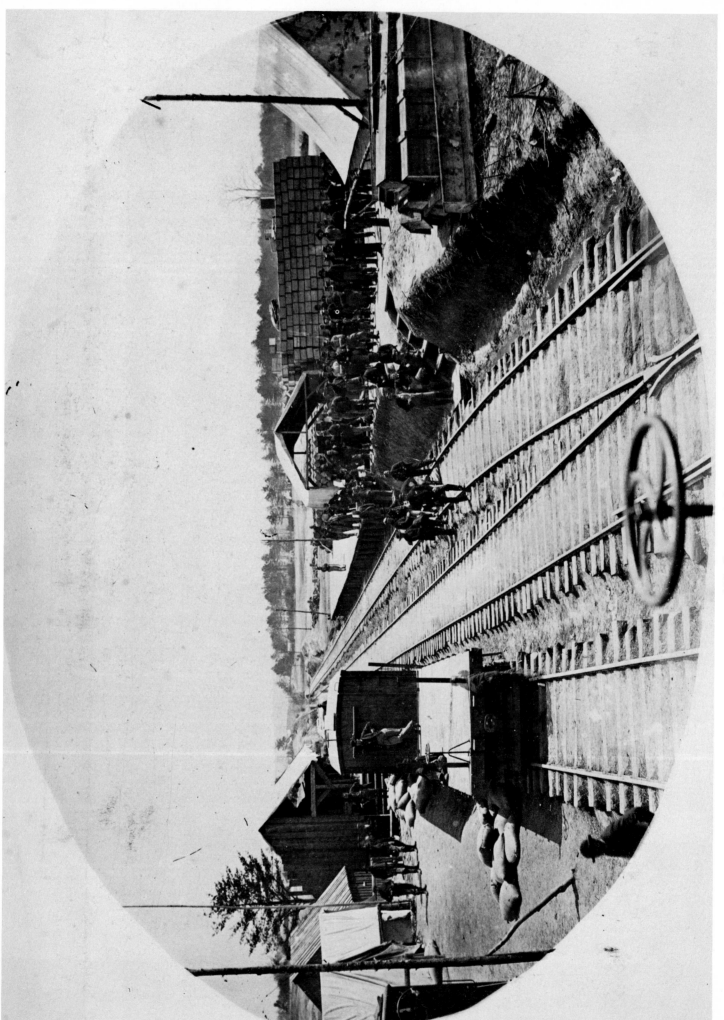

112. Stoneman's Station.

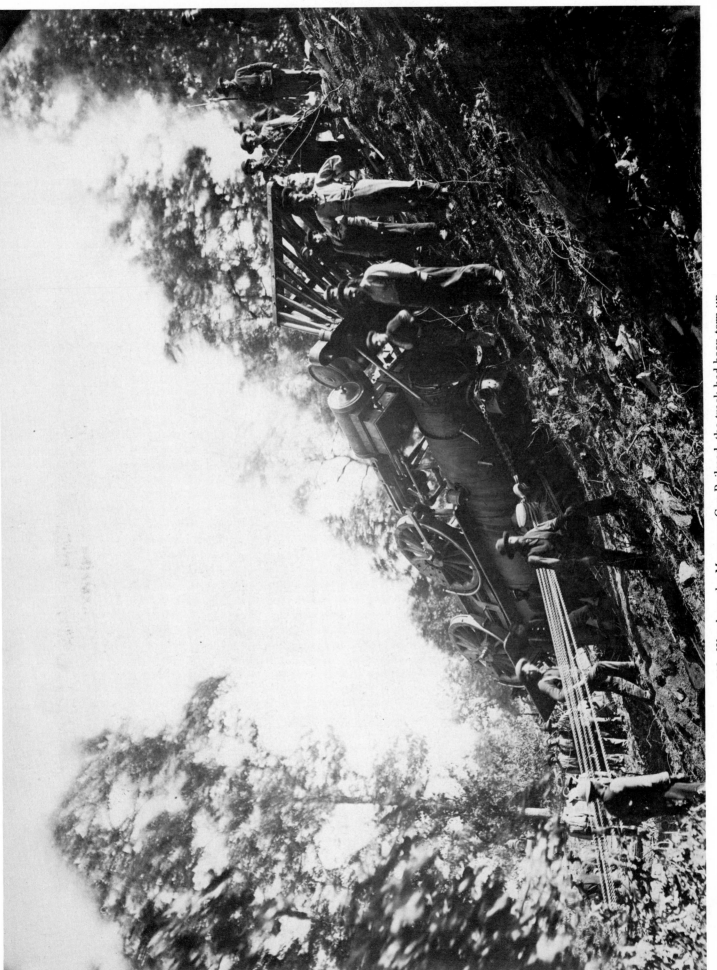

113. Wreck on the Manassas Gap Railroad; the track had been torn up by Confederates.

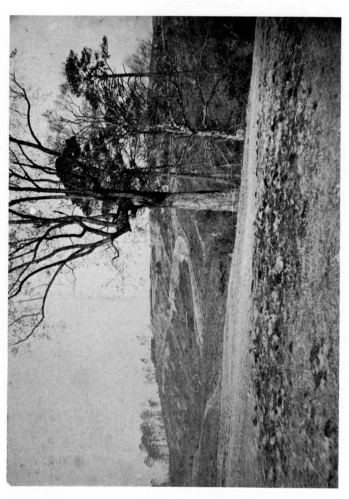

114. Distant view of Fort Brady, looking inland.

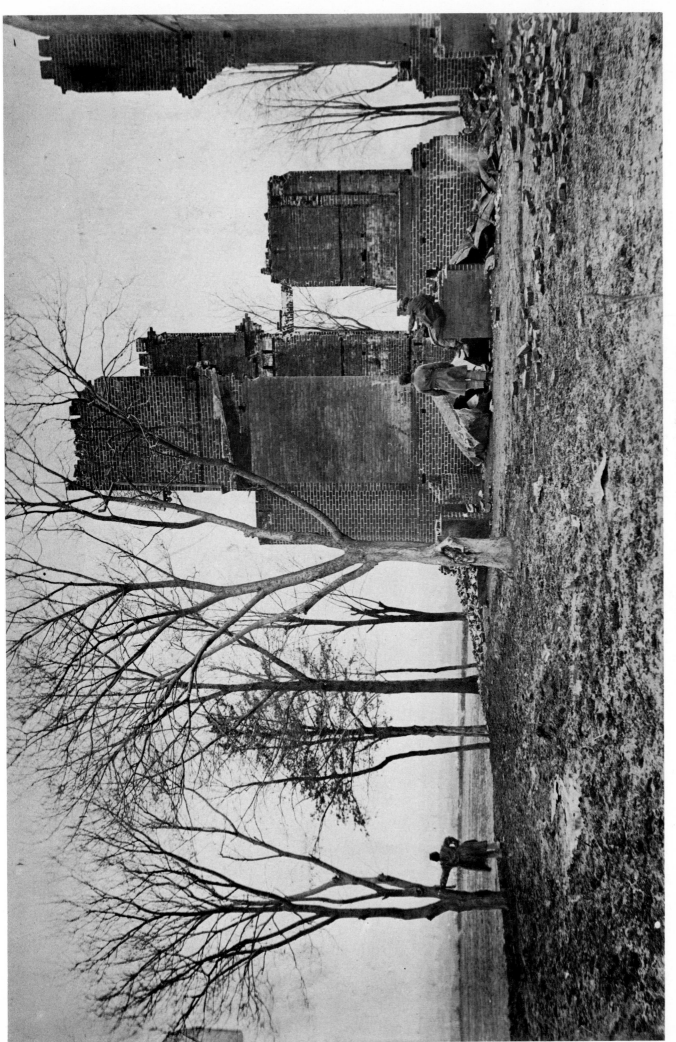

115. Ruins of Phillips House; Lacy House and Fredericksburg in the distance. [No. 178.]

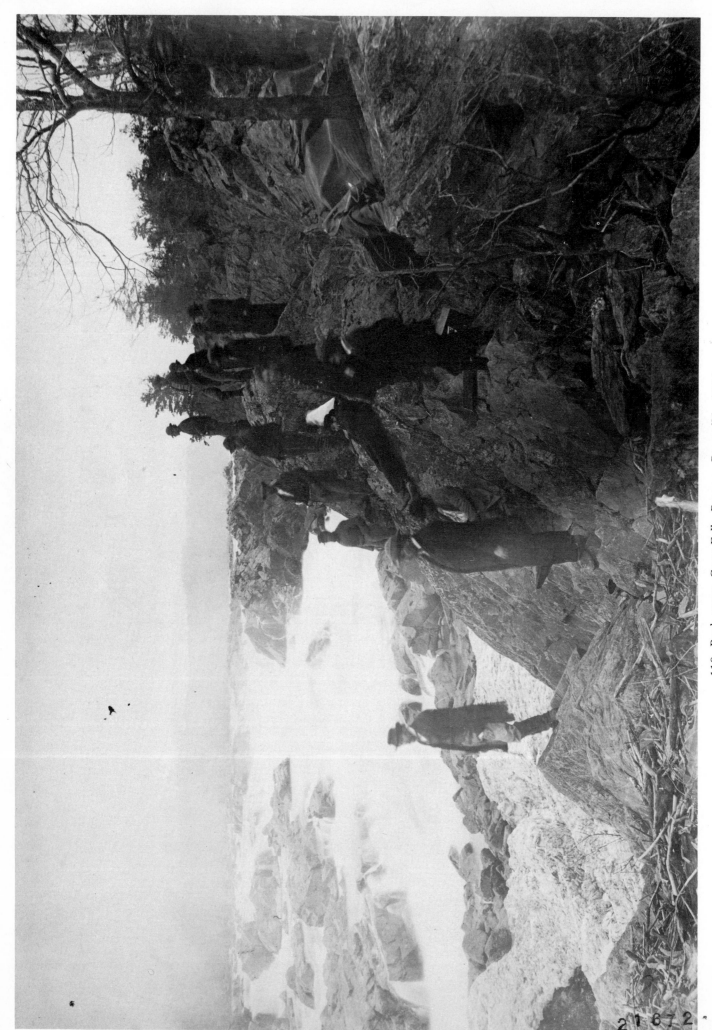

116. Rock scene, Great Falls, Potomac River. [No. 219.]